EMPIRE STATE
DE of CAY
DISCARDED NEW YORK

ALEX GULINO

AMERICA
THROUGH TIME®
ADDING COLOR TO AMERICAN HISTORY

America Through Time is an imprint of Fonthill Media LLC
www.through-time.com
office@through-time.com

Published by Arcadia Publishing by arrangement with Fonthill Media LLC
For all general information, please contact Arcadia Publishing:
Telephone: 843-853-2070
Fax: 843-853-0044
E-mail: sales@arcadiapublishing.com
For customer service and orders:
Toll-Free 1-888-313-2665

www.arcadiapublishing.com

First published 2020

Copyright © Alex Gulino 2020

ISBN 978-1-63499-253-4

Typeset in Trade Gothic 10pt on 15pt
Printed and bound in England

CONTENTS

ABOUT THE AUTHOR

ALEX GULINO was introduced to photography around age sixteen by her father. She quickly realized how much she enjoyed photography and felt especially good after winning a weekly photography contest for a local newspaper at age twenty. Later in college, Alex considered majoring in photography; alas, theater arts won out. While she put photography on hold to pursue an acting career, she never forgot her first love.

Years later, after beginning to travel the U.S. more and more often, Alex noticed how many amazing things she was seeing that just needed to be photographed. Her first love was reignited, and once again became a big focus in her life. Today, Alex travels as often as she can. Whether it be a simple camping weekend or a cruise to the Cayman Islands, her trusty camera is always by her side. It wasn't long before she discovered her love of abandoned sites and it has since become a big focus of her photography.

See more of Alex's work at www.alexgulino.com and on Instagram @starletlexy.

ACKNOWLEDGMENTS

This book would not be possible without my exploring and photography friends that have helped me so much along the way, namely: Mike Carroll; Karen; Alex; Tito; Heather; and Jon and Kristie. We've had so many amazing adventures together and those experiences would not be the same without you. I appreciate your sense of adventure and eye for art. Thank you, Mike, for all your kind editing assistance and encouragement.

Those closest to me have been my rock. I would be lost without my family: Alberto Gulino; Janice Gulino; and Michael Gulino and family. Thank you to Miriam Cortez for her friendship and guidance in writing, and Ruben Reyes and Victor Gosselin for their love and support. As well, my extended family, Nancy Alvarez, Paul Urquiaga, and Rosemarie Araujo have been so supportive and helpful along my journey and I am incredibly grateful.

For all their inspiration, I would like to thank Patrick from New Jersey Outdoors, Pete Green, Steven Bley, and Alexandra Charitan. For all their cheerleading, a sincere thank you to WIRW.

The pages I help moderate on Instagram have proved to be a great influence on my photography journey: @northjerseyadventures, @just_newjersey, and @urbex_supreme, and for that I am forever grateful.

Lastly, I would like to show my appreciation to Jay Slater for initially reaching out to me, Alan Sutton for his guidance, Kena Longabaugh for her assistance, and Fonthill Media for the opportunity.

INTRODUCTION

A cookie cutter existence was never appealing to me. I wanted adventure, but I did not quite come to realize that yet. One day, I stumbled upon two YouTube channels and a local newspaper article, and something in me was awakened. My inner explorer was born.

Urban exploration, or urbex, is nothing new. Urban exploration is the exploration of abandoned buildings or ruins and usually involves photographing such ruin. I have always had a fascination with those decaying secrets, but did not know there was a word for it. What I eventually came to understand was that there was not only a word for it, but a community of explorers who shared this common interest.

If you have ever wondered what lies behind the rotting walls of an abandoned building, this book covers an adventure through forgotten hospitals, poorhouses, and resorts throughout New York. While many of these institutions began with good intentions, with time, all were left to decay and eventually forgotten. Journey through spaces the public never gets to see, documented through poignant photographs, and explore the history that lives on in quiet desperation. From decaying homes to once thriving resorts in the Catskills, see what is left of those days gone by. While sometimes dangerous, these spaces have stories to tell. Learn about the adventures behind taking the photographs—crawling on the ground and under fences, sliding through icy, rotted halls, and of course, running out of sight from the public (so much running!).

To be clear, urbex is risky. Urbex, if you choose to pursue this hobby, requires you to often enter private property, access structures that are not stable, and possibly (probably) inhale pollutants like asbestos and mold, or come in contact with lead paint, etc. There are some unwritten rules about urbex as well: no breaking in, take only photographs, leave only footprints. I abide by these rules. Moreover, many explorers will not share the names of locations or coordinates. This is due to fear of the locations being further damaged or even bunt down. No urbexer wants that. In

light of this, you will notice that I have not disclosed specific information and tried to protect the locations in order to allow other explorers to enjoy them in the future.

Curiosity brings the adventurous to these abandoned places, to see what is decaying on the shelf, what is rotting in the closet, and what is crumbling in the bedroom. Enjoy this rare look into discarded spaces that offer visual wonder and insight as to what happens when the public walks away. While many seem to be quick to tear down the old and build anew, we, the explorers, understand that the abandoned still have stories to tell. We hope that you, too, will see the beauty in decay.

1

THE CATSKILLS RESORT

THIS AIN'T NO DIRTY DANCING

I heard that this place required a "hike" to get to it. What I failed to think of was doing that hike in the snow and ice. Winter is easier for exploring as there are virtually no bugs, less explorers, and less people out in general. While being detected is less likely, the snow and ice will get you.

After sliding down a hill for about a half mile, we finally arrive at the first buildings. This is a rather large property and fortunately for me, plenty of things were left behind to photograph. There are skis, ice skates, beds, and so much more. What a resort this must have been in its day. Funny enough, you can still find commercials for this place on YouTube.

There were other explorers there that day, which is always concerning as you never know if they are friend or foe. Fortunately, they were not concerned with us, and we were more concerned with all the ice we had to "skate" on. I guess no one ever said urban exploration is easy.

I eventually revisit this beautifully rotting resort to get a few more shots. I learn that this property is now up for sale again, as of October 2019, and I see there is new fencing around the famous circular building. Rumor has it that they are prepping the buildings to be demolished. We witness a lot of hazard like signage and strange pink spray paint with no apparent pattern. We later learn, from another explorer, that these markings and signage indicate where the dynamite will be placed when the buildings are eventually demolished.

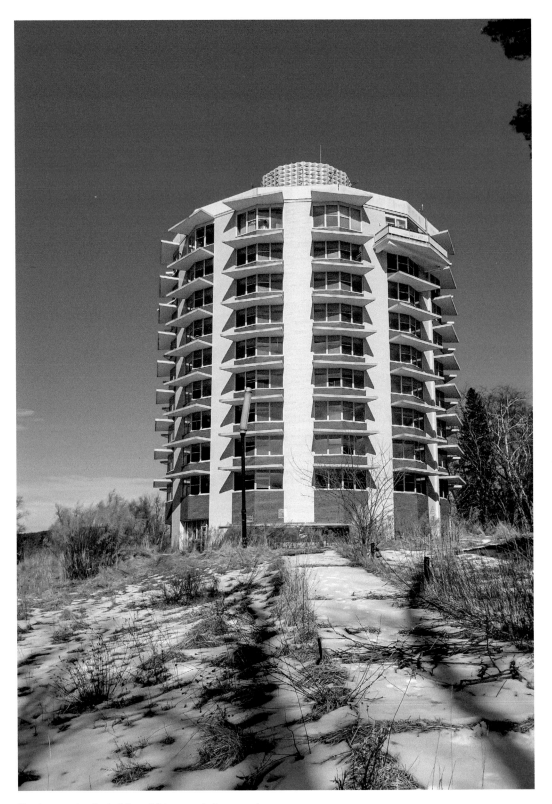

The famous circular building at this once glorious resort.

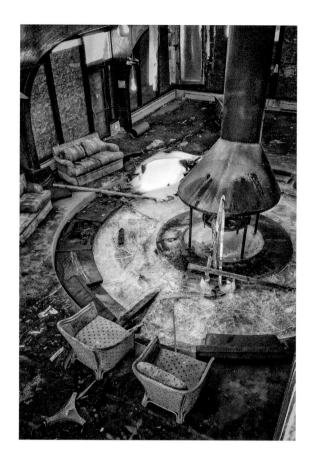

Right: Inside the ski lodge.

Below: Many of the rentable ice skates still line the shelves.

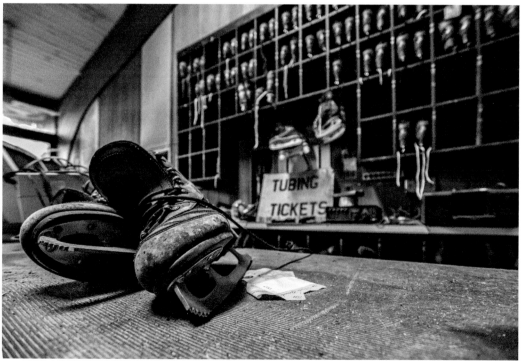

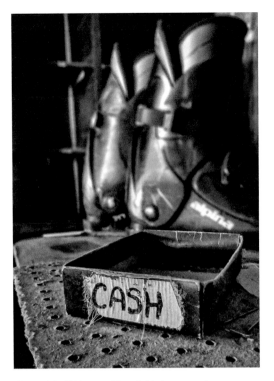

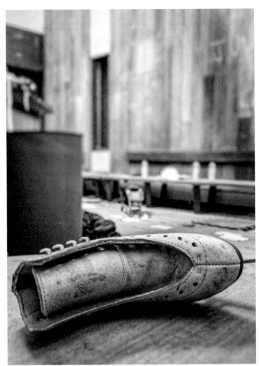

Above left: Ski boots still available in many sizes.

Above right: A female's ice skate rests.

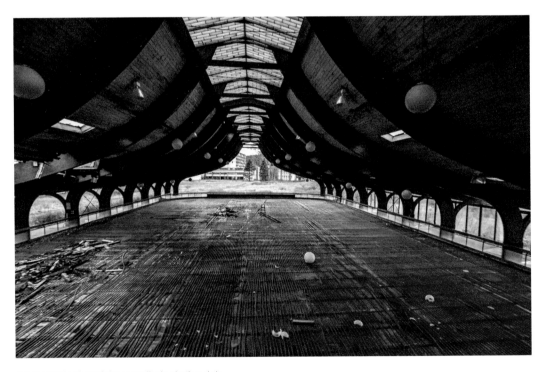

A panoramic view of the once lively skating rink.

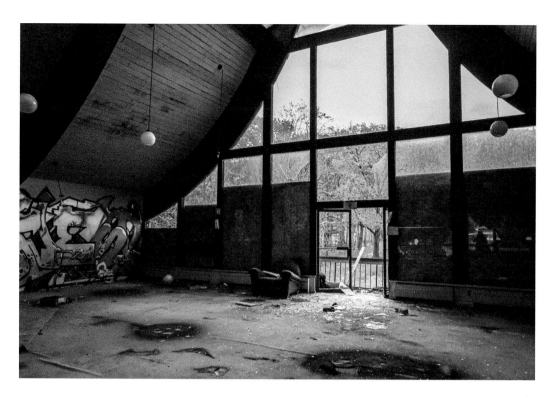

Above: Shattered glass gives way to the views of the Catskills landscape.

Right: Roof caving in over the once popular ski lodge.

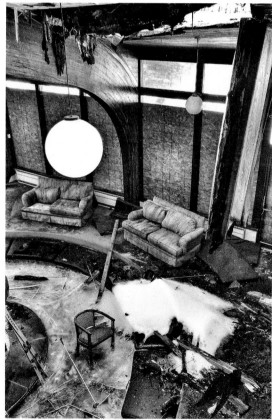

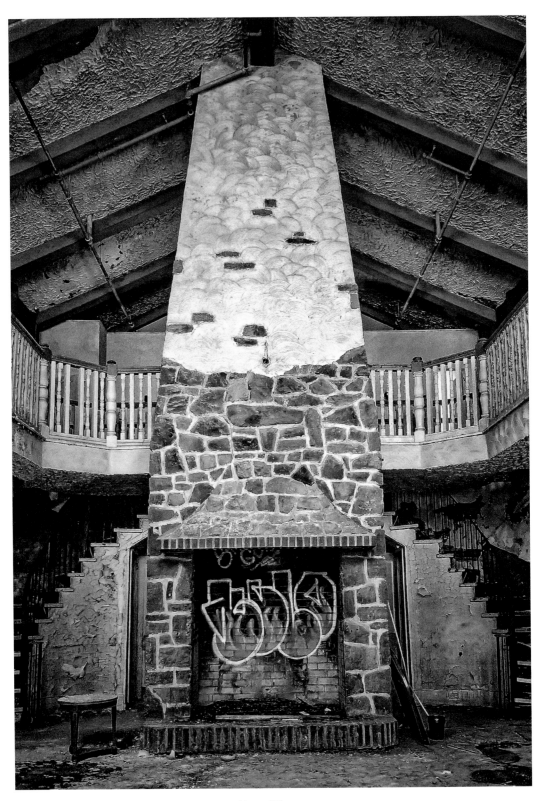

Sad to see this once beautiful fireplace now covered in graffiti.

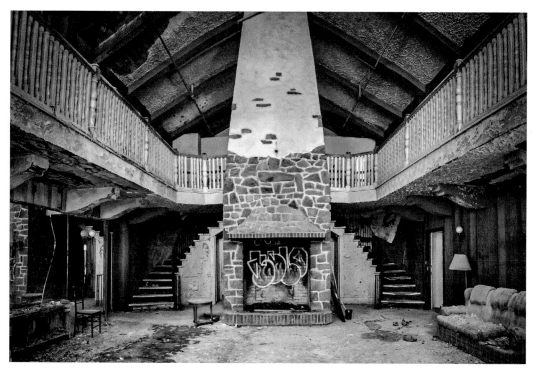
The grand fireplace is the centerpiece for this former lodging building.

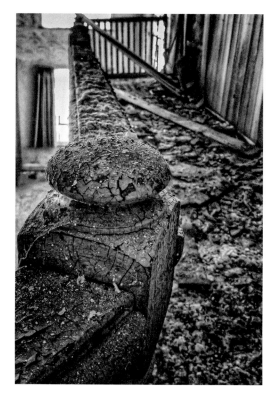
A now rotting railing leading to the bedrooms.

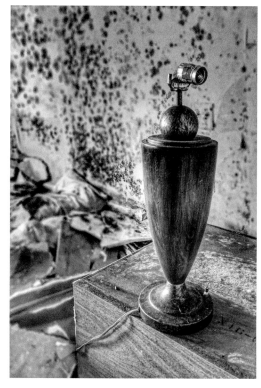
Old lamp found on a bedside table.

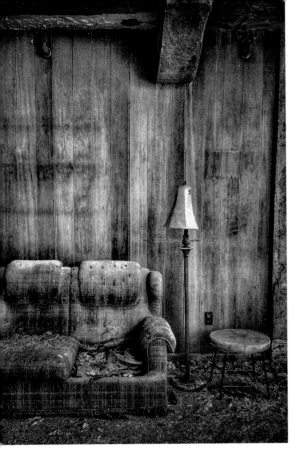

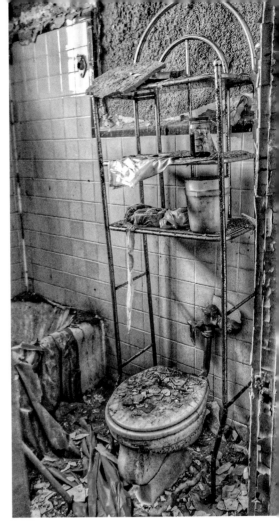

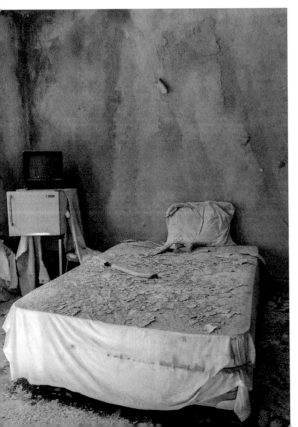

Above left: Decaying furniture left behind.

Above right: This colorful bathroom, complete with bathroom organizer, has seen better days.

Left: An old bedroom, which may have been for staff, still has many of its original furnishings.

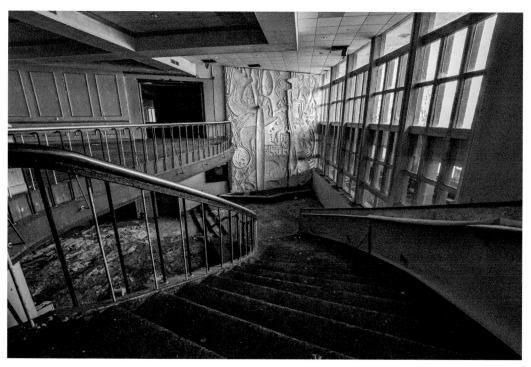

The grand staircase leading to a bar and stage area on the lower floor. We did not traverse these stairs as there was quite a bit of water damage.

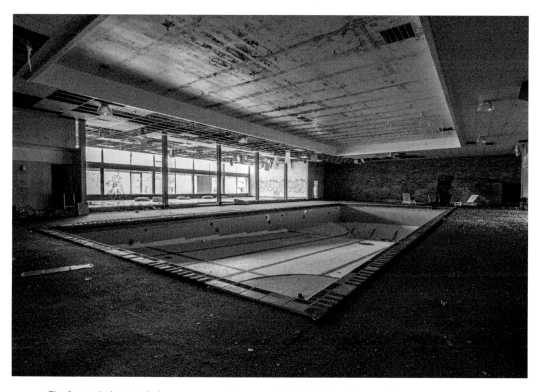

The former indoor pool where many vacationers would relax in the winter months.

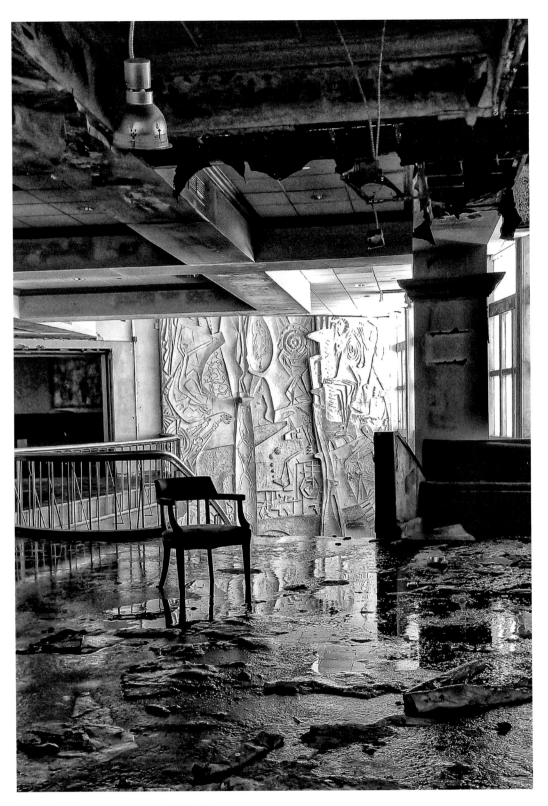

Above the grand staircase, a lonely chair sits.

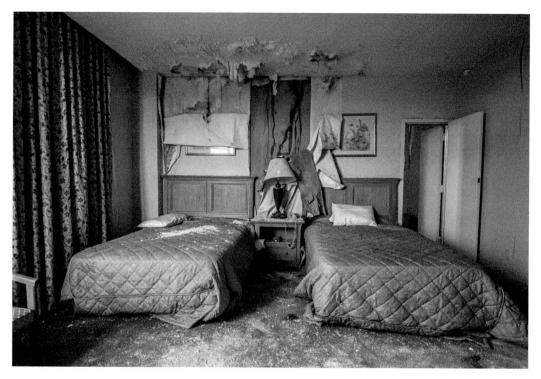

A bedroom from the top floor of the main building. Most of the more deluxe rooms at this resort can be found on this floor.

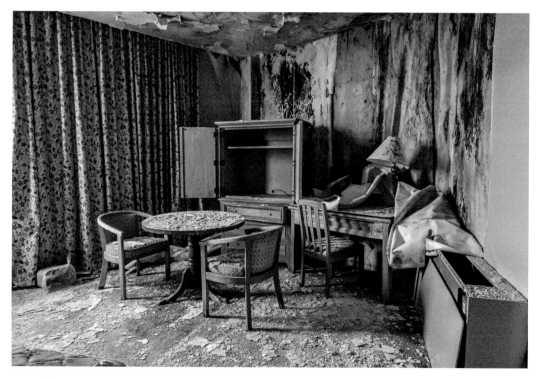

Bedroom furniture and walls from this deluxe room sit in a permanent coat of mold.

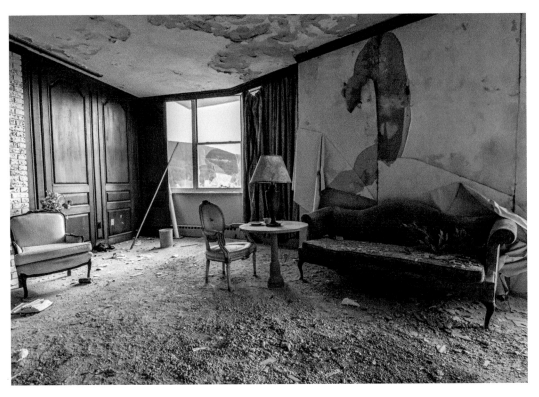

The grand suite with much of the furniture still in place.

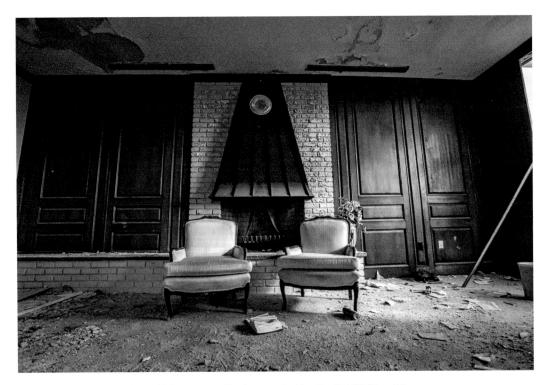

The grand suite was complete with its very own fireplace overlooking the Catskill Mountains.

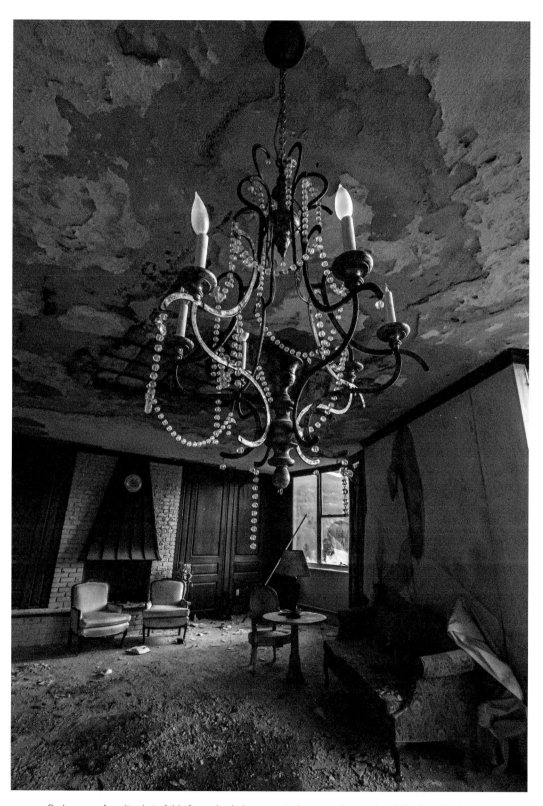

Perhaps my favorite shot of this formerly glorious resort, the once elegant chandelier found in the grand suite.

2

THE POOR HOUSE

CROPSEY WAS HERE

Abandoned properties with a possible association with a local boogeyman might be terrifying to some. I am not one of those people.

The "Poor Farm," as it was originally known in the 1830s, is a local legend in the Northeast. After seeing photos and videos online years ago, I knew I had to see this place for myself. It is massive. I did not appreciate the size of this property until I saw it with my own eyes.

Upon entering the first building, of what I believe are a grand total of ten buildings, the sheer awe of the age and size of the place hits you. These buildings are close to 200 years old with the facility closing in 1975. Richmond County created this place for those less fortunate to work (farming vegetables, tending to farm animals, etc.) for room and board. Eventually, the aging population of the Poor House forced the facility to no longer require their residents to work for a roof over their head.

Entering this place requires tip-toeing around a residential middle-class neighborhood, where everyone knows that the Poor House attracts many curious explorers. Your goal is to find a break in the fence surrounding the property without being detected. With new fencing being put in recently, as the property has been sold to a developer for one dollar, it becomes more challenging.

While I walk through these halls, my main thoughts are: do not fall down the empty elevator shafts, avoid other people (are they just explorers? Or someone come to do you harm?), and stay away from bees who seem to swarm the place in the summer. Seeing places like this makes me awestruck. While progress is good, tearing down historical places may not always be the answer.

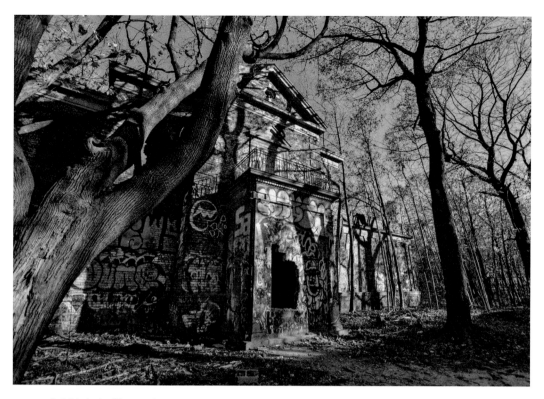

Outside look of the poorhouse.

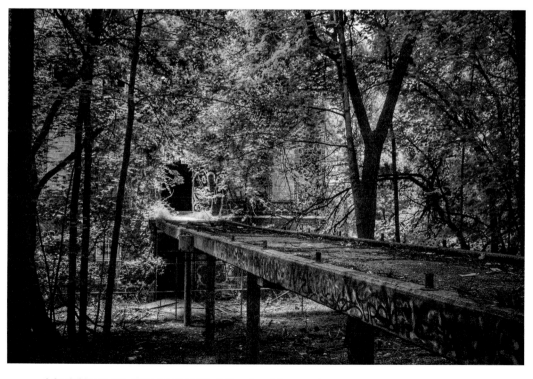

A footbridge to one of the many buildings found on this property.

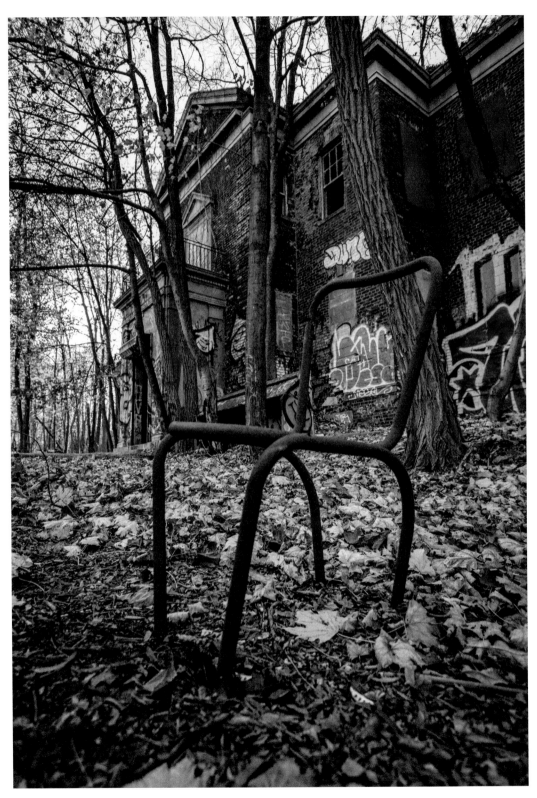

A rusted chair frame found with one of the many buildings in the background.

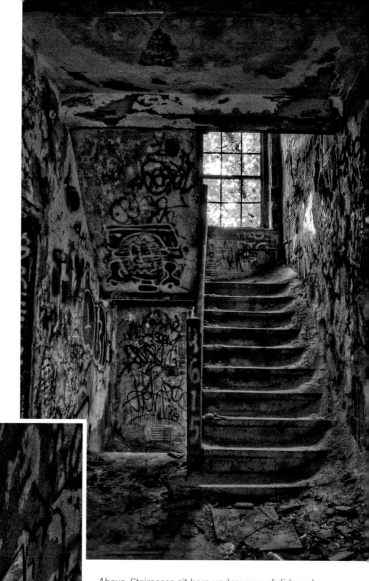

Above: Staircases sit here under years of dirt, and presumably, asbestos.

Left: Long, empty hallways line the space of the former poorhouse.

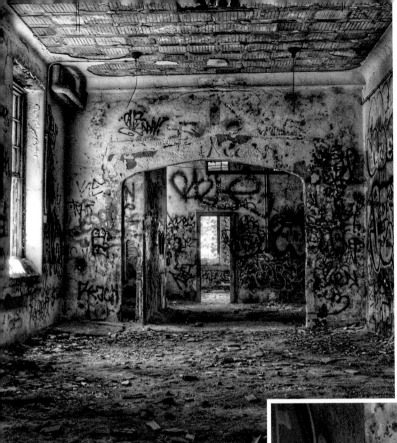

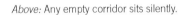
Above: Any empty corridor sits silently.

Right: These walls have seen much graffiti over the years. Many of the walls include Instagram handles of visitors from the past.

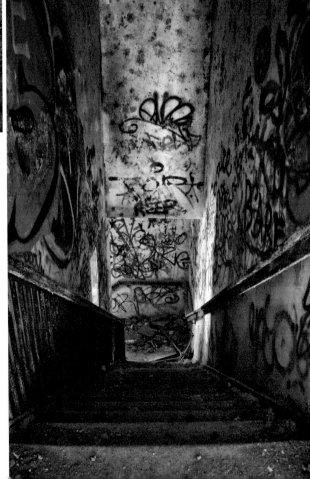

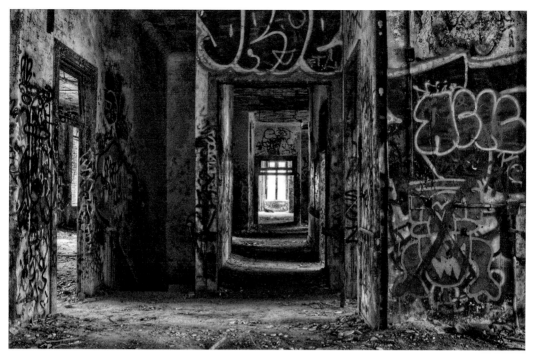

Huge empty spaces found throughout the property.

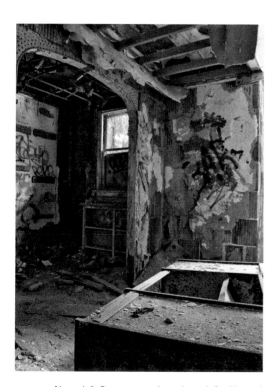

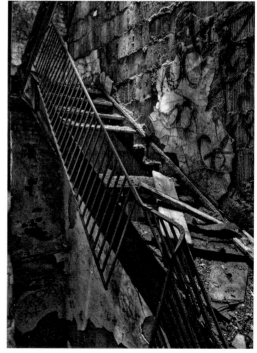

Above left: Some rooms have been left with equipment left behind.

Above right: One of the many staircases that can no longer be traversed here.

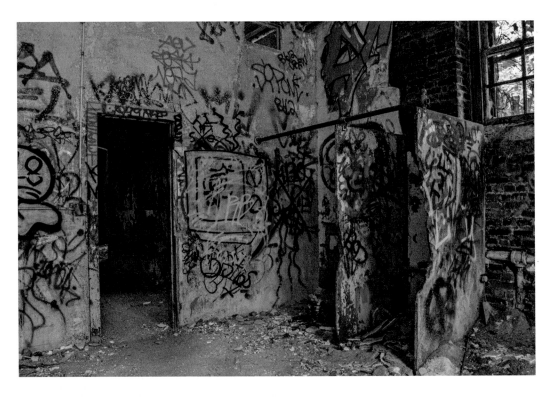

Above: Shower stall walls still standing in the bathrooms.

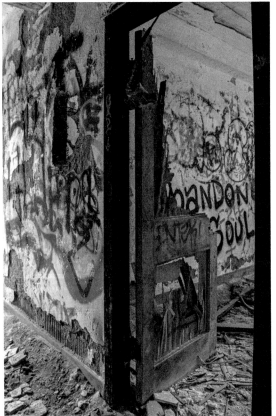

Left: A partially collapsed door to one of the dorms.

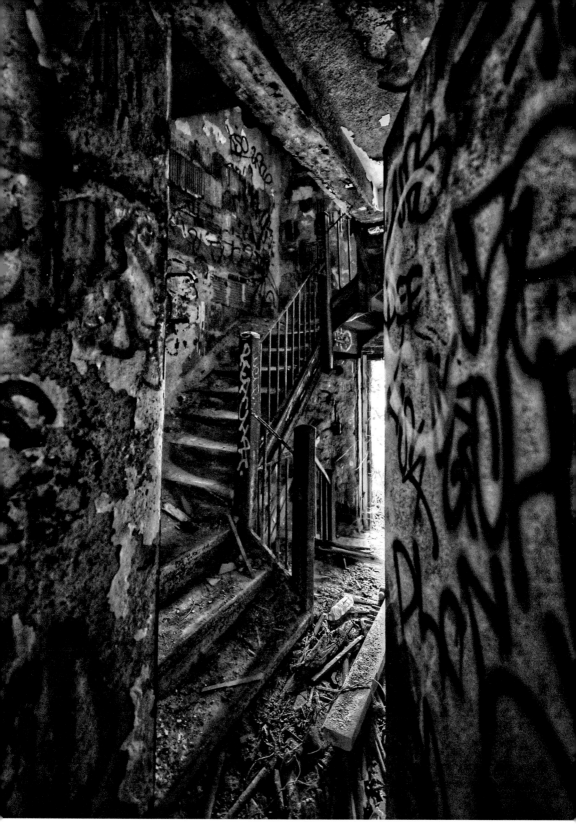

A staircase leading to other floors with much damage.

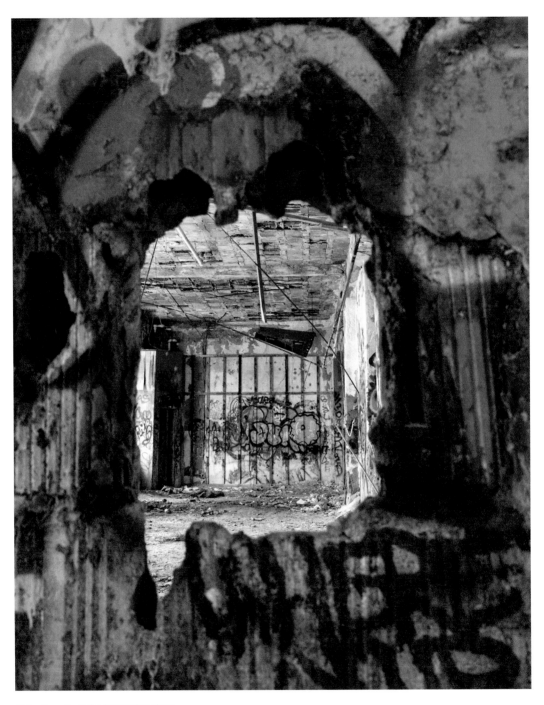

Holes in walls make interesting views.

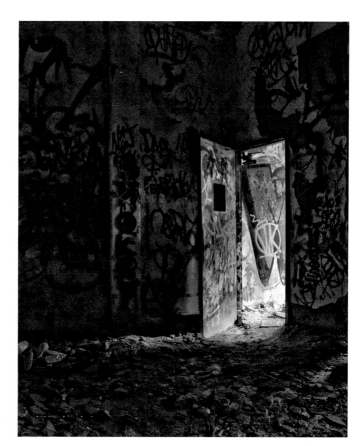

Right: A frozen doorway gives way to light.

Below: Urinals found in an old bathroom.

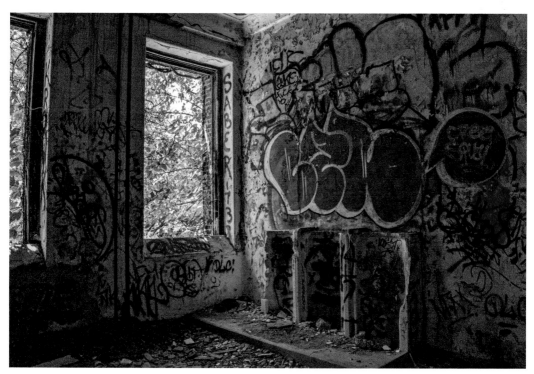

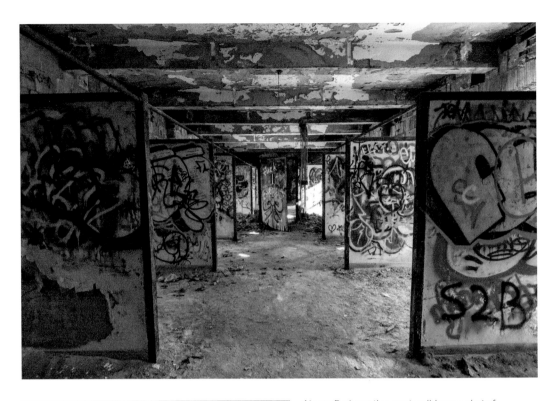

Above: Perhaps the most well-known shot of the poorhouse, it seems that these walls were some sort of divider between workspaces.

Left: If it ain't pretty, put a bow on it.

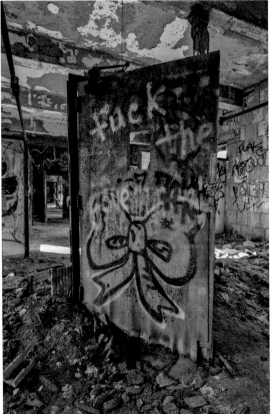

3

THE ABANDONED ASYLUM

WHERE HOPE COMES TO DIE

If it wasn't for Geraldo Rivera, I would bet most of the public would not know of the horrors here. Whether you believe in ghosts or not, there is no arguing there is an uneasy feeling to this place, as my friend and I quickly discovered. We arrived at a parking lot, maybe half a mile or so from the asylum, on a summer morning. It was hot, which was not conducive to a lot of walking, but urban exploration is a labor of love. We try to "casually" walk onto the property, which is easily visible to the street, with plenty of cars coming by. Dark clothing is your friend in these instances.

We arrive at the first building, and I am full of excitement (and anxiety). Typical day at the bandos, you know. I had heard of this place ages ago and it has been on my bucket list to see it. I'm finally here. Wow. I enter the first building and immediately my friend has a bad feeling and she opts out. I have no idea how many buildings we will be able to access, so I am not passing up the chance. I will say that I rarely enter buildings alone—don't try this at home, kids—but it's beautiful: peeling paint, discarded furniture, and cracked glass. The asylum has it all.

We make our way to some other buildings. We find their power plant, numerous hospital beds, and a recreational space complete with a stage for performances. Disappointingly, there are a ton of discarded patient files. My friend, who works in the mental health field, was entertaining herself with those records. Based on everything I have heard about this place (unclothed patients, unwashed children, zero activities to keep the residents occupied), I'll assume those files are full of lies about the true state of the patients. While walking through this space, it is hard to forget the stories of those that had suffered here.

In some back buildings, which appear to be offices, we find more discarded furniture: desks, couches, periodicals, and strange sounds. I felt the entire time we were there that someone was watching us. Active imagination? Perhaps. Once we heard another loud, very nearby sound, we knew our time here at the asylum was done. We were the lucky ones who got to walk away.

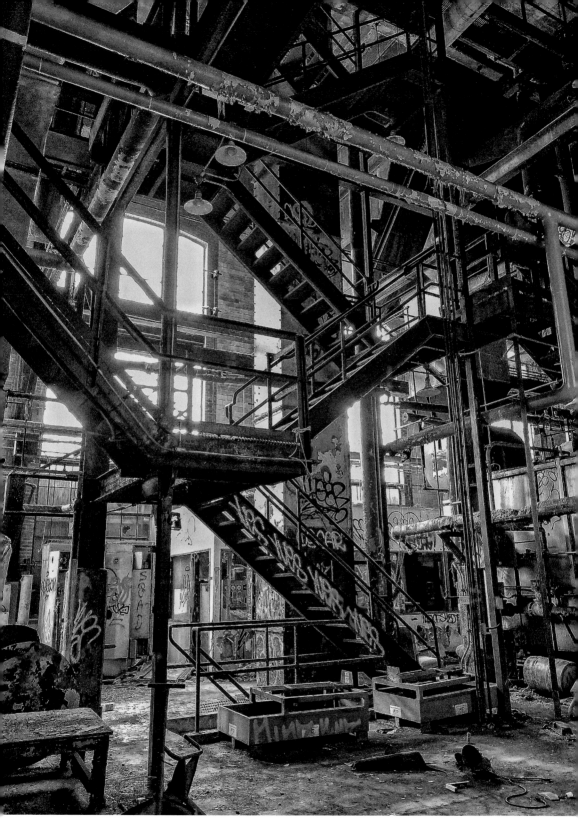

Inside the asylum's power plant.

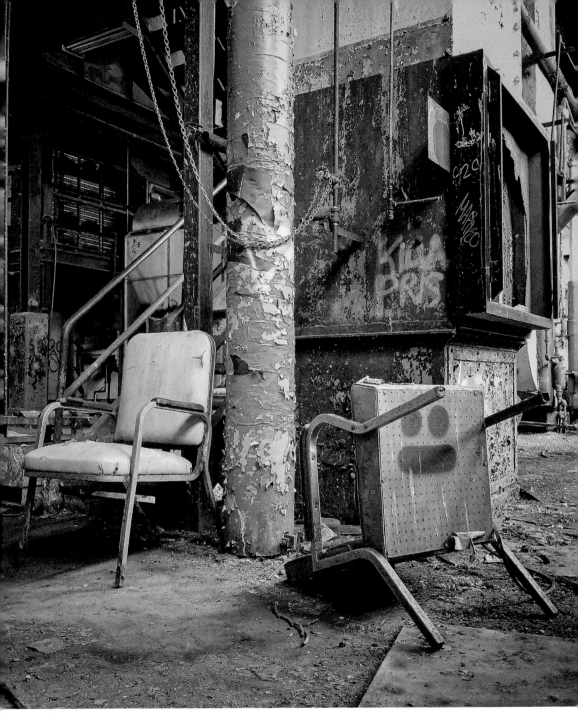

Quite a bit of discarded furniture can be found here.

OPPOSITE PAGE:

Above: A colorful array of decaying seating rots at the power plant.
Below: A doorway leads to more filth.

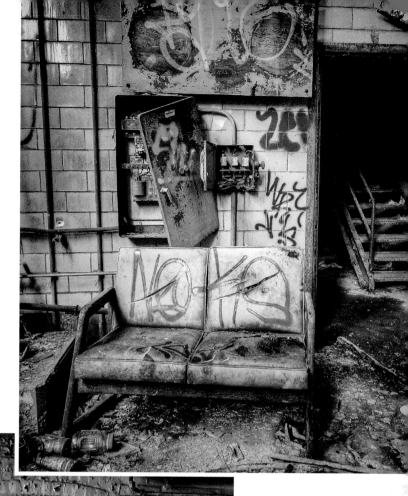

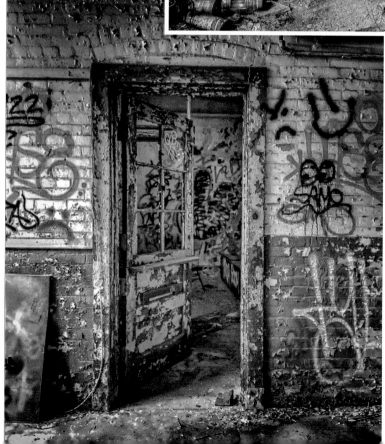

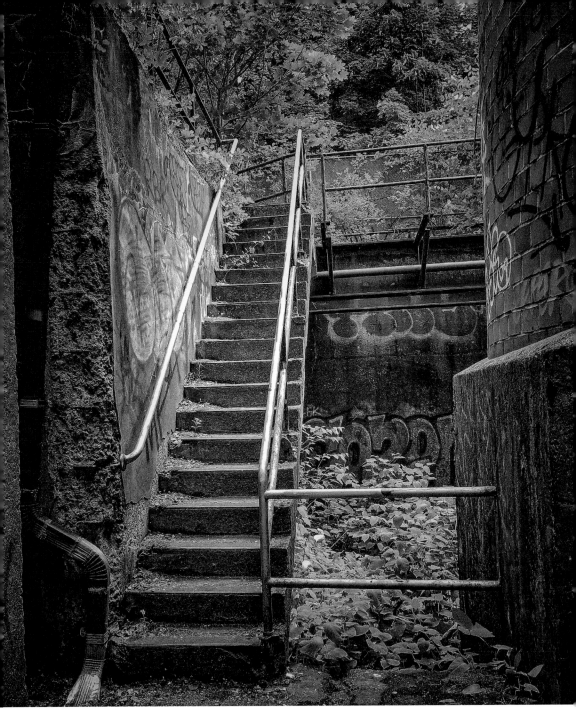

Staircase leading out of the power plant.

OPPOSITE PAGE:

Above: Some furniture here seemed posed.
Below left: An old classroom found with curtains still intact.
Below right: This classroom comes complete with own antique typewriter.

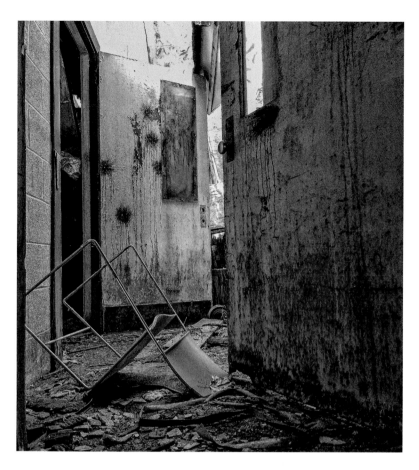

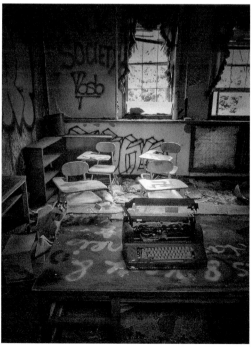

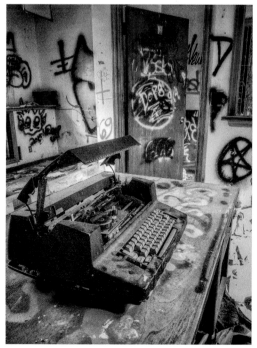

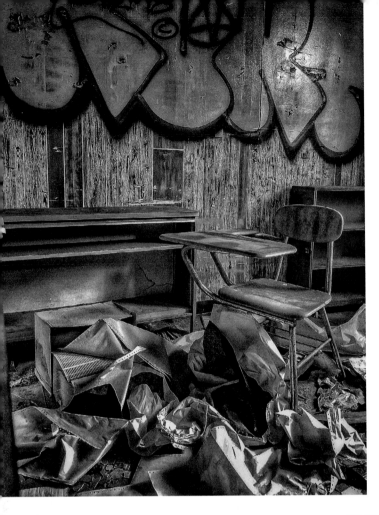

Left: Though it seems to be reams of old computer paper, we found no computer.

Below left: A classroom desk sits empty.

Below right: This decaying staircase caught my eye.

Opposite page: This was a small stage area where we can assume the patients would be entertained—at least, at one point.

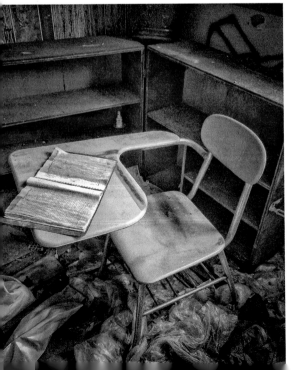

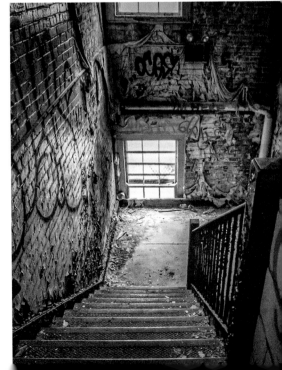

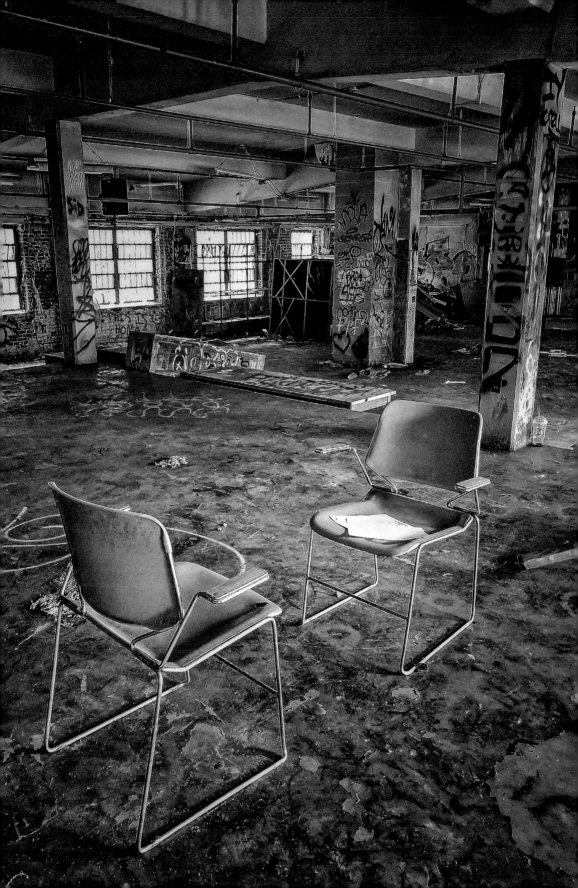

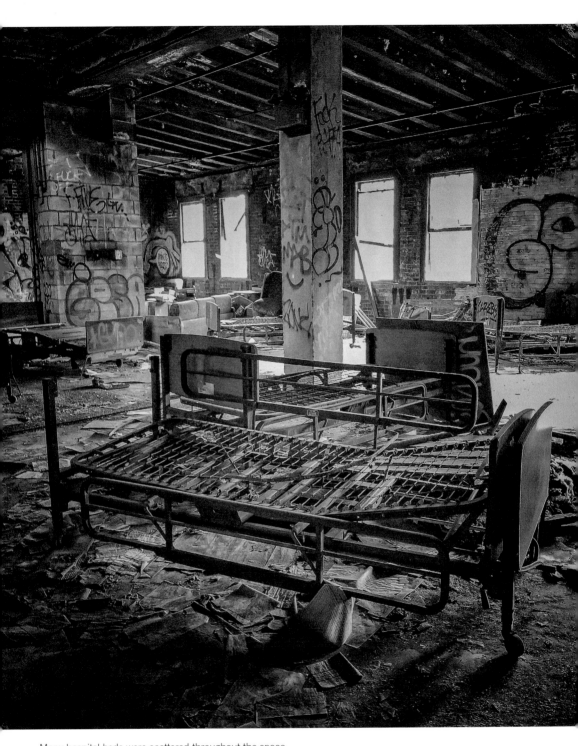

Many hospital beds were scattered throughout the space.

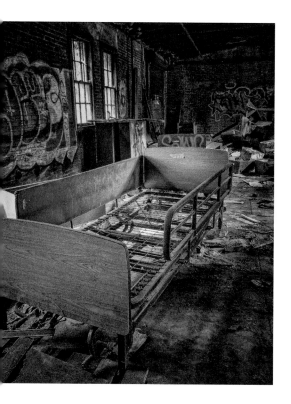

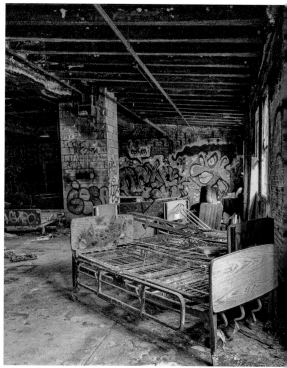

Above left: Along with these many hospital beds, many patient records were found as well.

Above right: Many found it necessary to spray paint the walls here.

Right: This old filing cabinet was found in the back offices. Unfortunately, we were unable to open the filing cabinet.

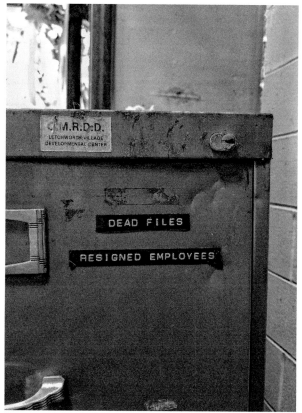

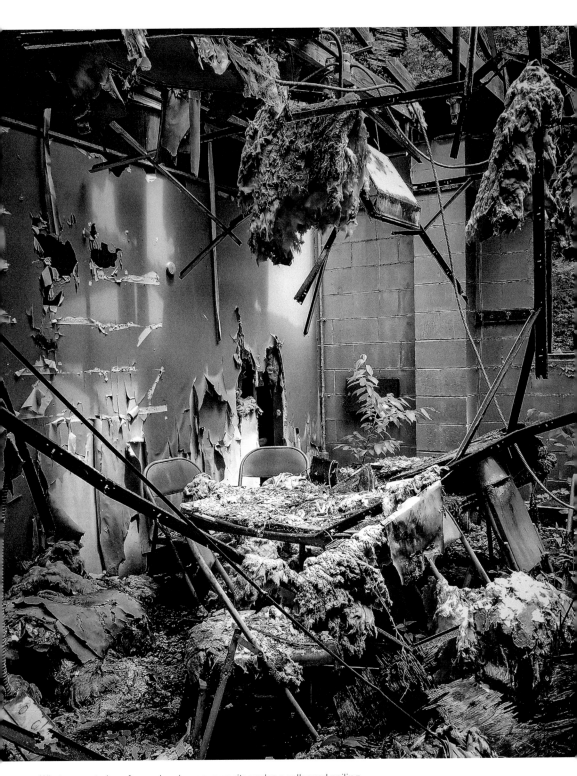

What seems to be a former break room now sits under a collapsed ceiling.

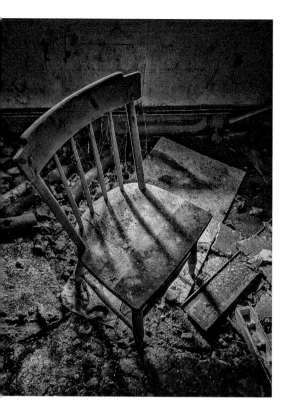

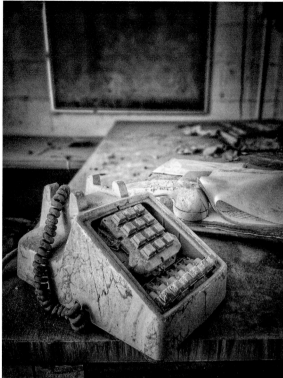

Above left: Beautiful rotting chairs can be found throughout the space.

Above right: Sorry, wrong number.

Right: An old chair hides the mold-filled bathroom.

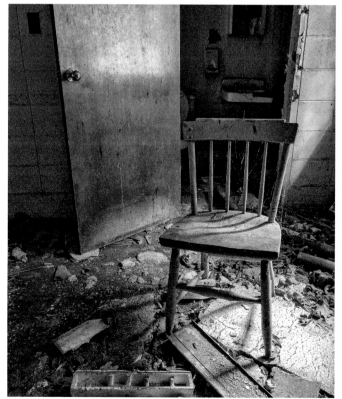

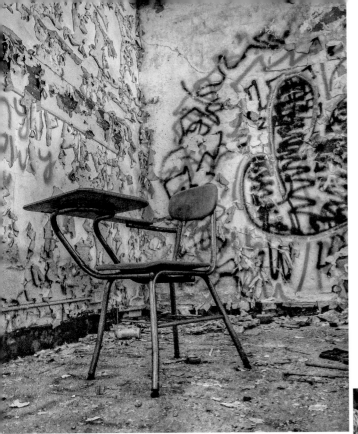

Left: An incongruous spot for a classroom desk.

Below: I stumbled upon what appeared to be a workshop near the back offices.

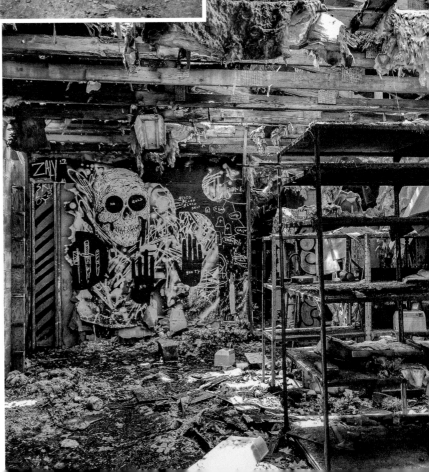

4

WINTER AT THE CONVALESCENCE HOME

A CHRISTMAS STORY

It was a chilly Christmas morning when we went exploring. The week or so prior, an explorer I follow on Instagram posted in her story, "Anyone want to go exploring on Christmas day? HMU." While I did not know her personally, I saved the idea in the back of my head. After all, I had nothing to do on Christmas day since my family celebrates on Christmas Eve. "Maybe I will take this girl up on her offer," I thought to myself. A few days later, I messaged her, "Hey, I'm Lexy. Are you still looking for someone to explore with on Christmas day?" Fortunately, she was. I met her Christmas morning in some strip mall parking lot. Getting into a car with a complete stranger on Christmas day to take a long ride to see an abandoned building was probably one of the strangest things I have done in the name of adventure. That chilly morning, off we went to Westchester County.

As she parked the car, she told me that this place was a convalescence home. We climbed through some brush, got caught on what we call "sticker bushes," and crawled under a fence, all while trying not to be seen by some nearby functional businesses where people were coming and going (no easy task). Once we entered, it was beautiful. There was a grand piano in the main hall. This baby was beautiful.

Afterwards, we go upstairs and I briefly believe that I have locked myself out from the stairs heading down and out. I cannot even describe the panic I feel at that moment. My worst nightmare is happening: I am locked in a bando, no one knows I am here, what am I going to do?! Fortunately, I quickly figure out that I am simply grabbing the door from the wrong handle and all is well again. We come upon a room where many lamps, sans shades, are placed. I do not know how or why, but I do think it is art. I think to myself, "Oh my stars … this is the room I've seen a dozen times online, and now I'm here. This. Is. Awesome."

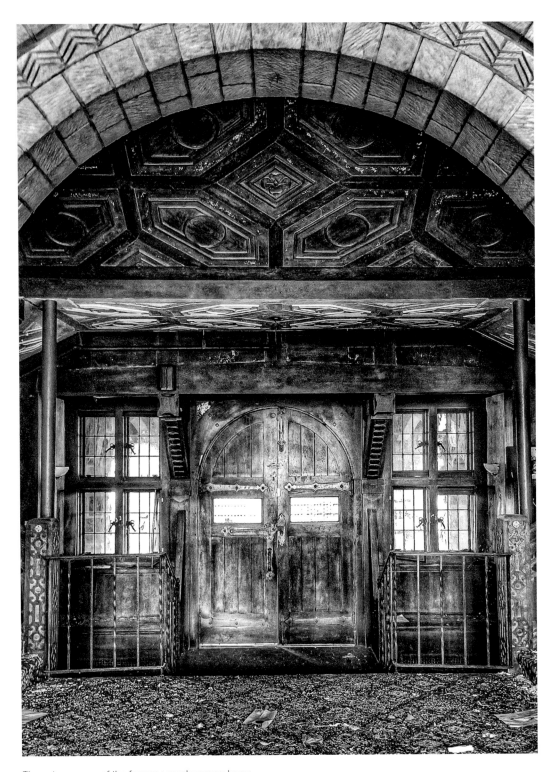

The entrance way of the former convalescence home.

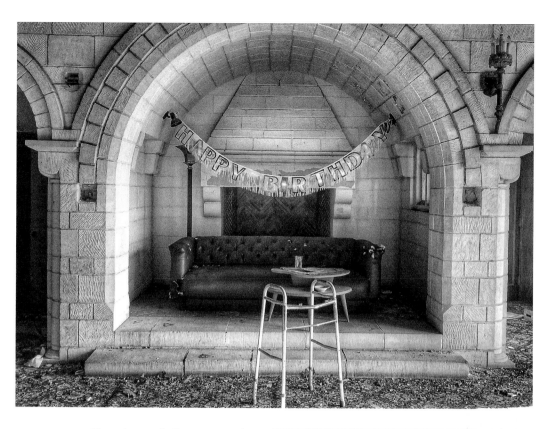

Above: Apparently, it was some party.

Right: The toilet is just down the hall.

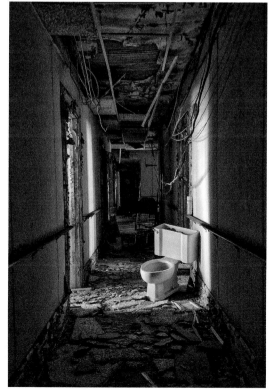

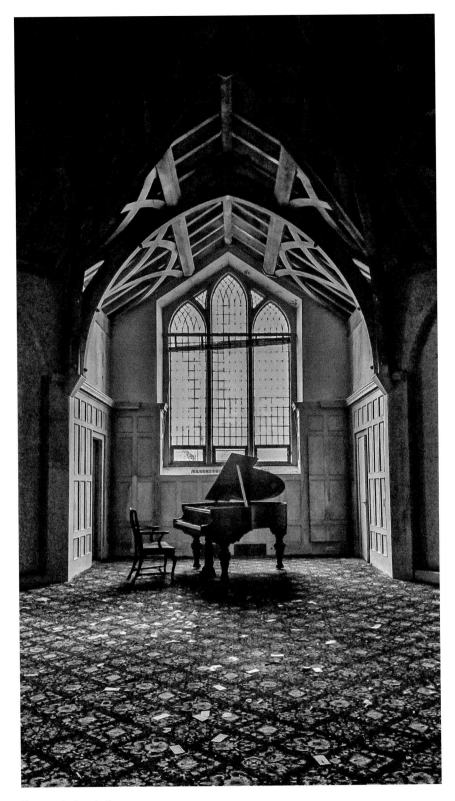

The grand piano in the common area.

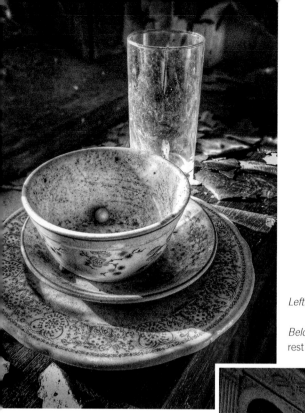

Left: Many dishes and china found still at the property.

Below: One of the many fireplaces at this once glorious rest home.

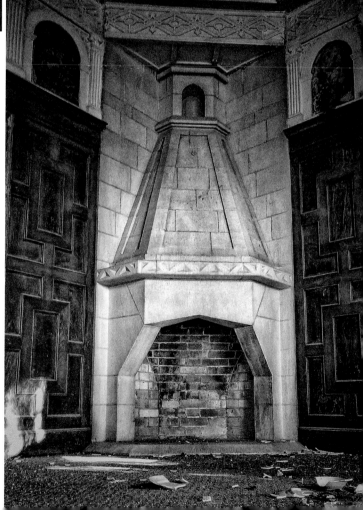

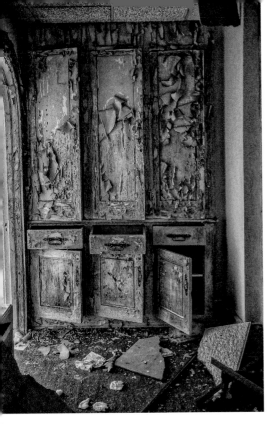

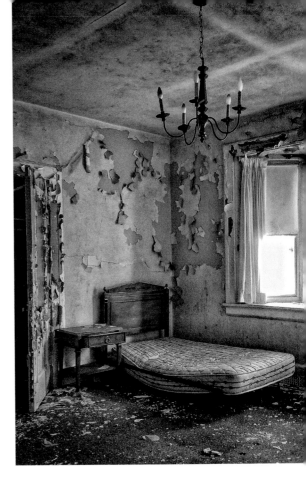

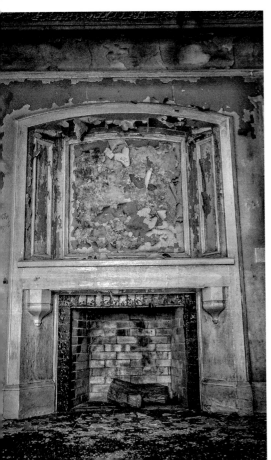

Above left: Empty cabinets and drawers covered in peeling paint.

Above right: Many of the bedrooms here were painted in pleasing pastel colors and furnished with simple chandeliers.

Left: Hard to believe there was still wood in this fireplace.

Opposite page: Bedding on former beds is always a big score in an abandoned place.

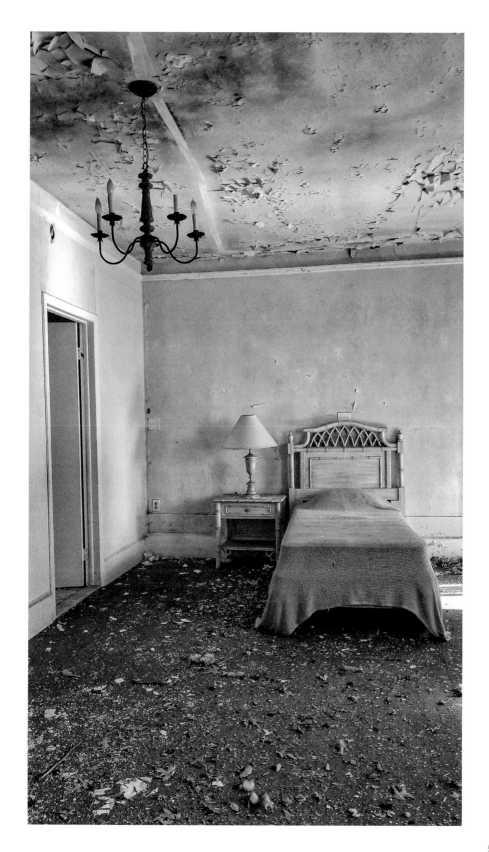

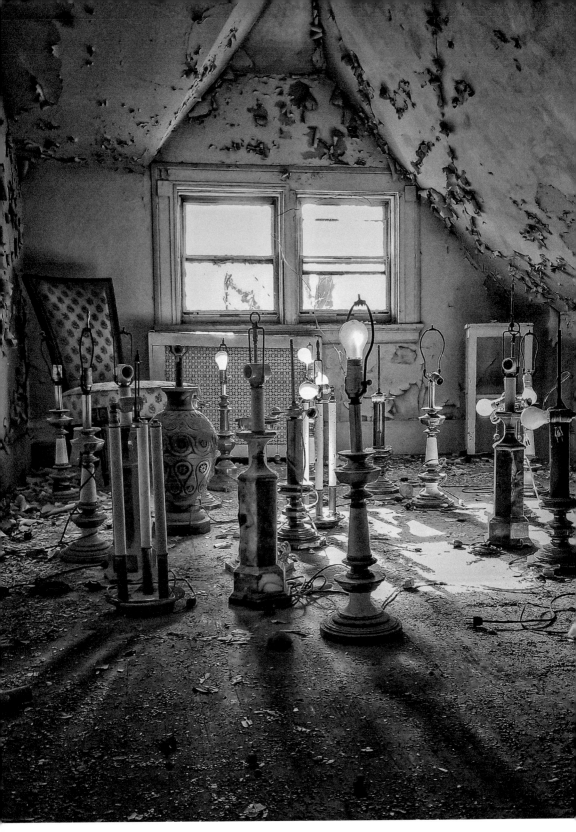

So many lamps were placed in this one room for an unknown reason, maybe just to create art.

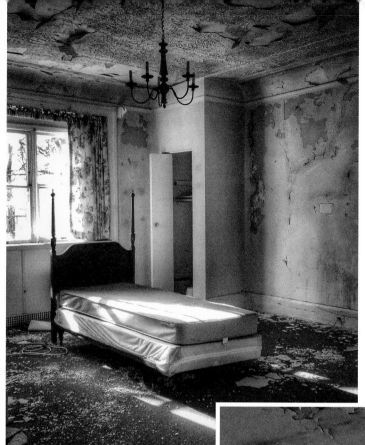

Above: More pastel colors with floral curtains for this bedroom.

Right: A famous fairy tale lives here.

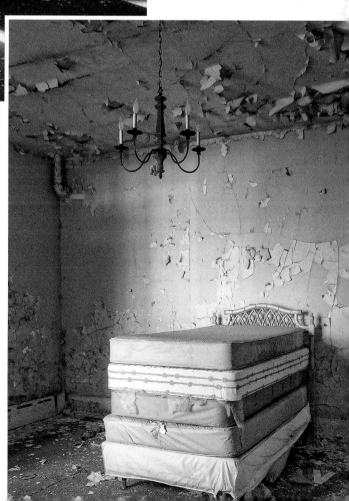

5

THE BRICKWORKS

About an hour north of Manhattan, you can find a building, a former brick factory, that once made millions of bricks over fifty years. Some of these bricks even made it into the one and only Empire State Building. Eventually the brick factory closed due to local clay supplies drying up. Many years later, the state of New York purchased the property and turned the area into a park. While you will find many signs warning "No Trespassing" around the building, curiosity got the best of me.

I enter a big open space, which I can only guess was the factory floor. Nature is taking over the space with cracks in the concrete and growth coming through. I turn the corner and find what seems to be one of the largest pieces of machinery I have ever seen in person. I am unsure of its function but am fascinated by its rusty facade.

There are so many people nearby, as this is a park, so I keep freezing to hold my breath as I do not want to be discovered when I hear a passerby. I was told many times by family members who are in law enforcement to never mess around with government properties. I am not trying to learn that lesson the hard way today. I would like to be clear here and remind you that I am a photographer. I am there to simply document what is there.

I enter another room to find these two circular mounted objects that cannot be clearly identified. Some suggested that they are old urinals, some suggested they are a type of sink. In any case, it seems I have stumbled upon some kind of washroom area and it is beautiful to me. I head up the stairs to see what awaits me there. The floor is barren except for some graffiti that explorers from the past have left. There is a huge cutout in the floor where you can easily drop straight through to the bottom floor. Most abandoned places have signs to stay out simply for liability reasons. If you are not careful in these spaces, one could easily get hurt or worse.

There are often no railings on which to hold, no warnings about that hole in the floor, and no alarms to advise you about the poor air quality. You truly do proceed at your own risk.

I take some more photos of the space and imagine what this once busy brickworks must have looked like in its heyday.

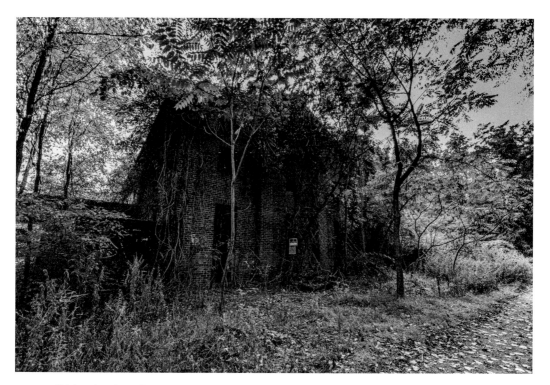

Brickworks: stay out.

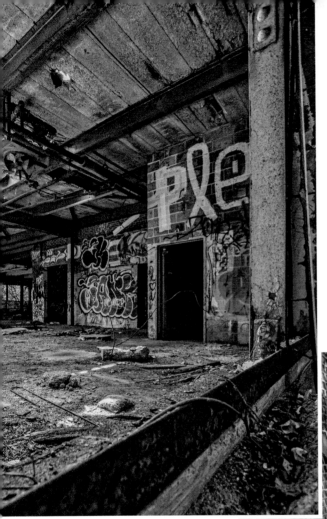

Left: This is where I climbed in.

Below: A gated door opens to a colorful staircase.

Opposite page: I'm not sure of the purpose of this large machinery, but it was impressive.

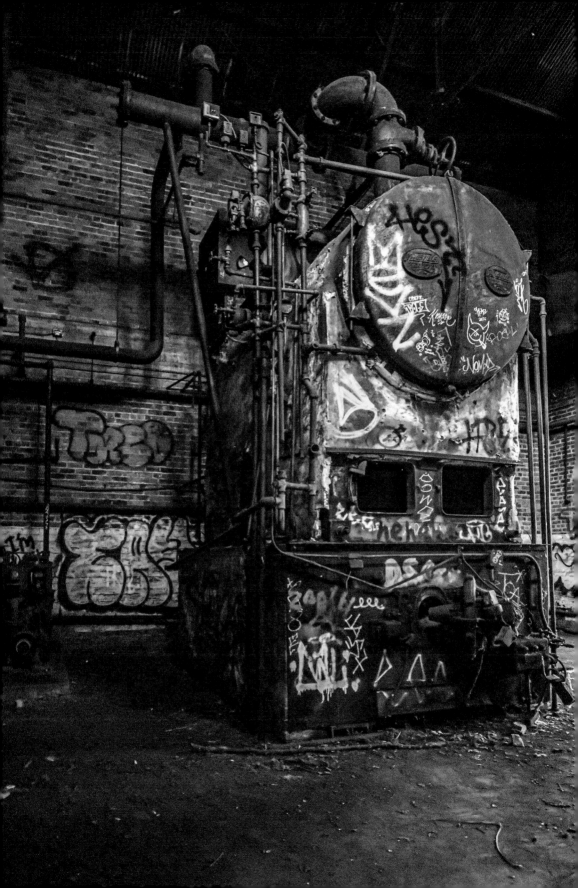

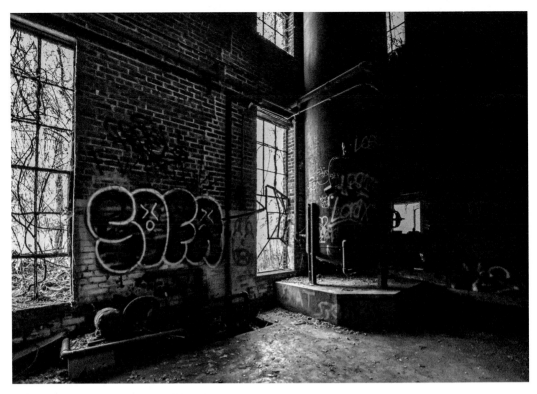

Inside here, I could hear the locals just walking around the park enjoying the day.

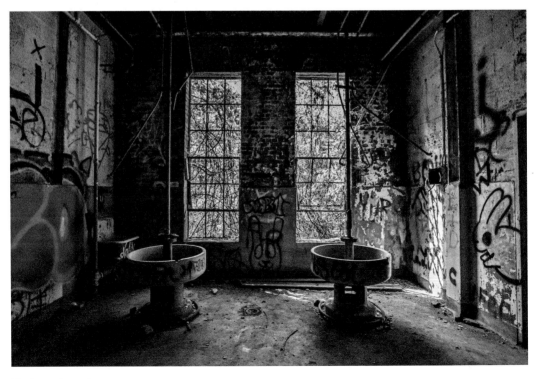

Shadows of a washroom.

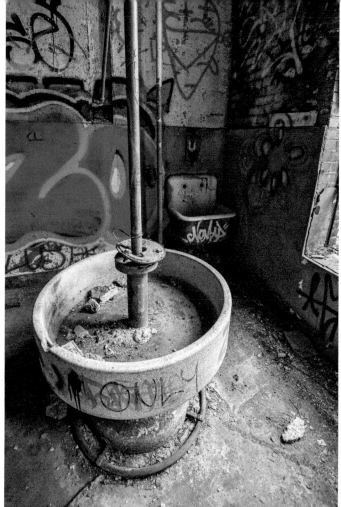

Above: Urinal? Sink? You decide.

Right: The ominous staircase.

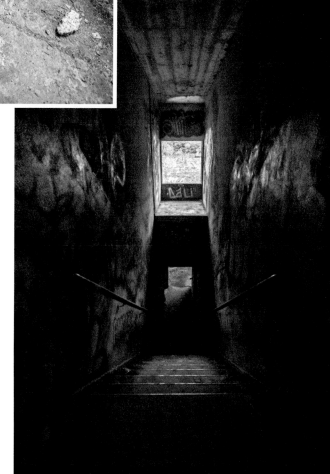

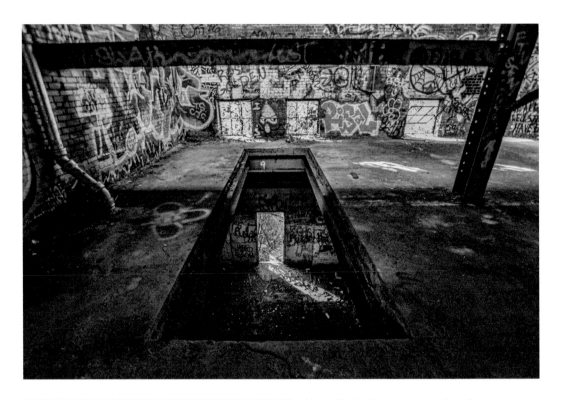

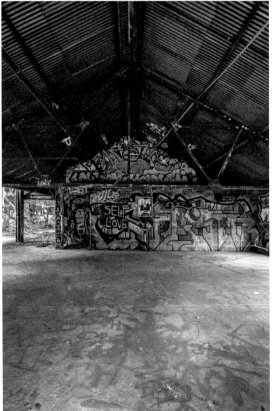

Above: The top floor shows an alternative entrance to the building.

Left: Graffiti covers these otherwise barren walls.

6

CAT LADY HOUSE

BUT WHERE ARE THE CATS?

The Cat Lady House, as they lovingly called this one, is in a somewhat rural section near the Catskills. My number one observation in the Cat Lady House was there was no sign of any feline friends. Go figure. Mold? Sure. Leftover clothes, television set? Got it. But no sign of cats. I have always been curious about homes where so much is left behind. What happened here? Why would the occupants leave in an apparent rush? What secrets do these walls hide? What have these walls witnessed that these discarded belongings cannot tell us?

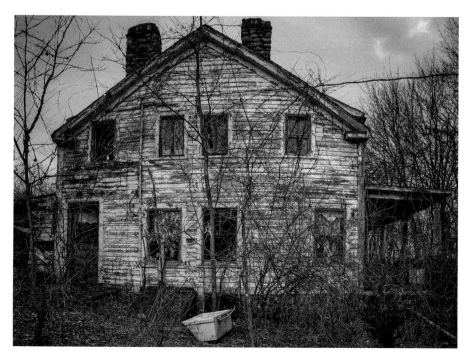

Winter at the Cat Lady House.

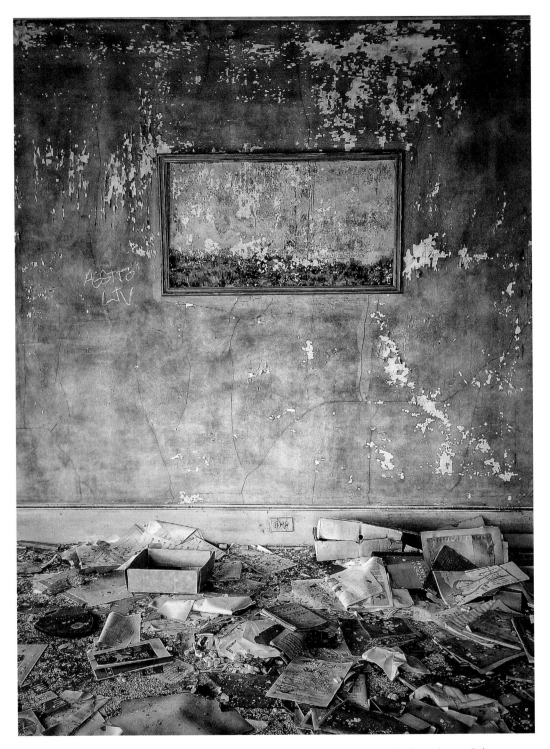

Clothing, art, etc. left in this space. Someone suggested this art was actually on the wall itself and not a hung painting.

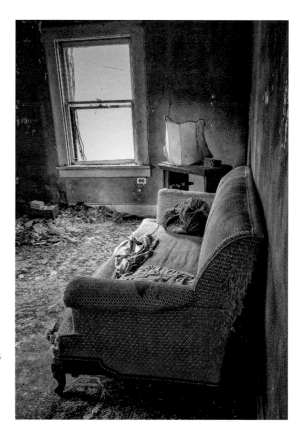

Right: All signs of your average middle-class living room found here.

Below: They just don't make them like they used to.

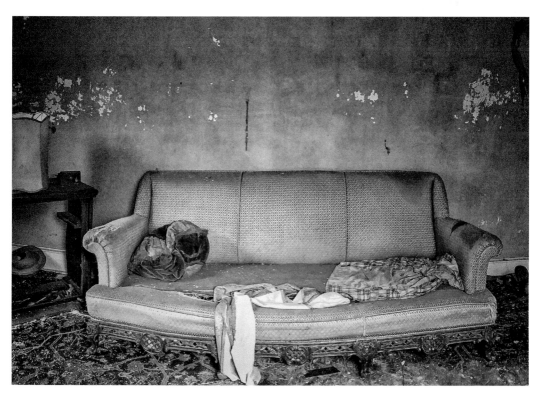

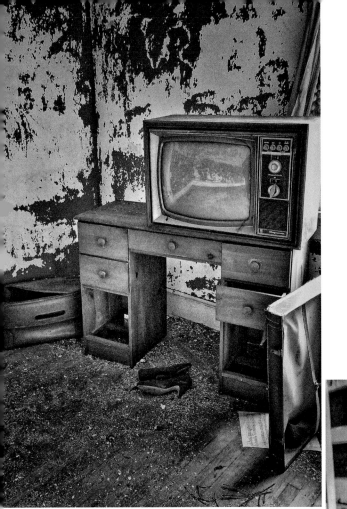

Above: Why would the occupants leave without their electronics? And their shoes?

Right: Much more clothing to be found here.

7

THE BED BUG MANOR

THE RESIDENTS (AND BUGS) HAVE CHECKED OUT

I've seen many photos of this place over the years, and spent some time trying to research its location. Luckily, I found a blog to get me on my way. I asked my friend who visited the convalescence home with me on Christmas if she wanted to go an adventure. She happily agreed. We crept up the driveway and were greeted by a beautiful wheelchair right in front of the manor. This felt like a good sign. We enter the building to our right and begin our exploration. We realized quickly this is one of those places where it is going to be a challenge to find the exact spots we want to find. Fortunately, I had reached out to some friends that visited recently and they provided me with some guidance.

When we finally arrive at the cafeteria, we are happy to see that the old booths are still present, and they are glorious. With plant life growing inside the windows and walls, it's easy to see that while man will continue to build all the structures it wants, nature will always find a way to survive.

This manor, formerly a hospital, was an adult home that had been shut down by the Department of Health. In addition to other issues, the main deciding factor in closing the facility was due to bed bugs and mold, unwelcome visitors in any space. As of November 2019, there was a meeting to be held inquiring about the possibility of applying for an EPA clean up grant for the property. I am not sure where the property stands at this point, but I am glad to have visited the place before alterations occur. Of course, not all abandoned properties lay dormant forever, and often it's a race against time to visit spaces before the landscape is changed permanently.

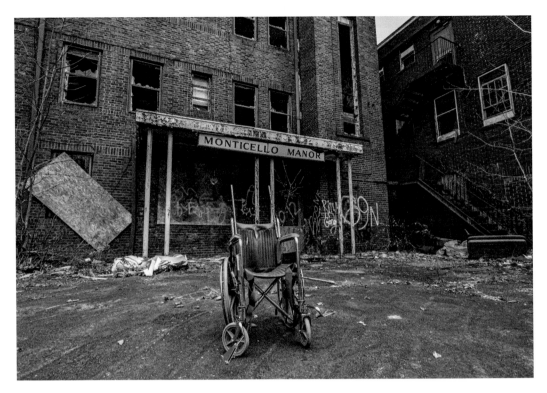

Welcome to the manor.

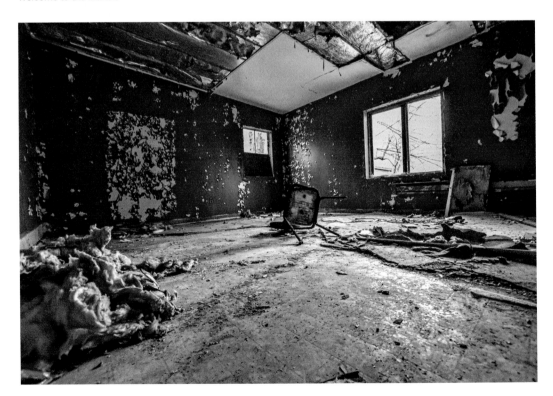

Discarded furniture found in darkly painted rooms.

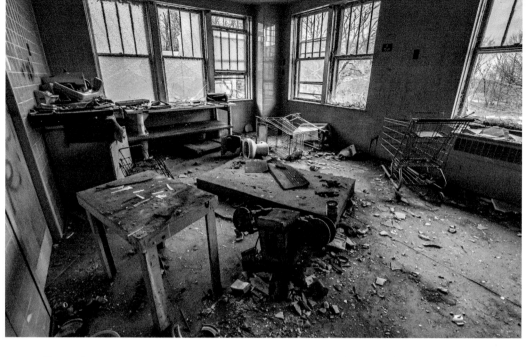

Above: I found many forgotten shopping carts in this building, and I'm unsure what function they served here.

Right: Staircases are kind of a favorite of mine. I can't resist photographing them.

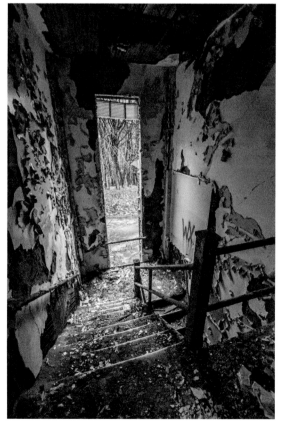

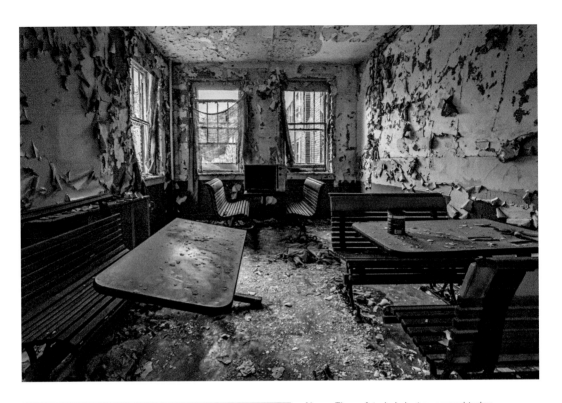

Above: The cafeteria is just swamped today.

Left: We'd like to reserve a table for two.

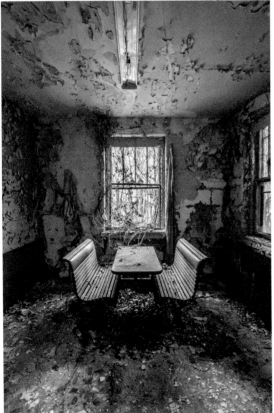

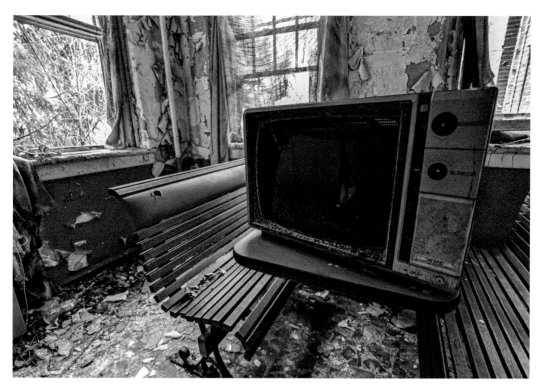

Along with your fine dining, we can offer you the latest in entertainment.

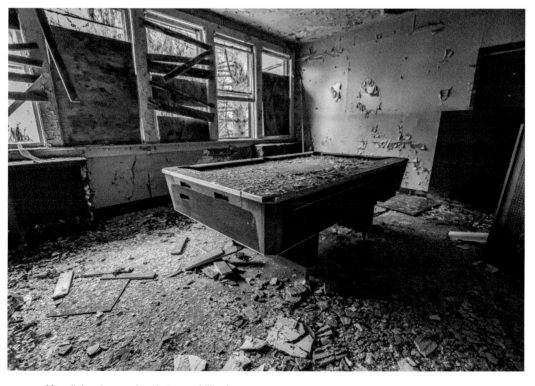

After dining, try your hand at some billiards.

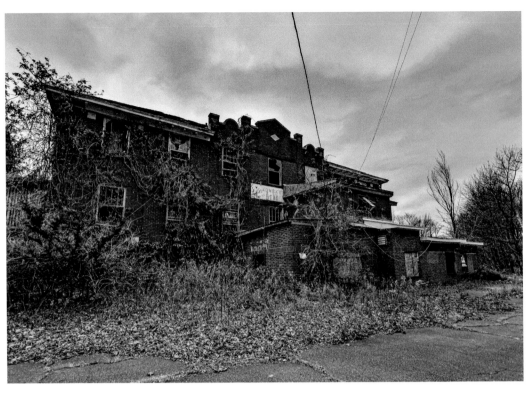

Before it became the manor, the space was a hospital and here a sign of the former name.

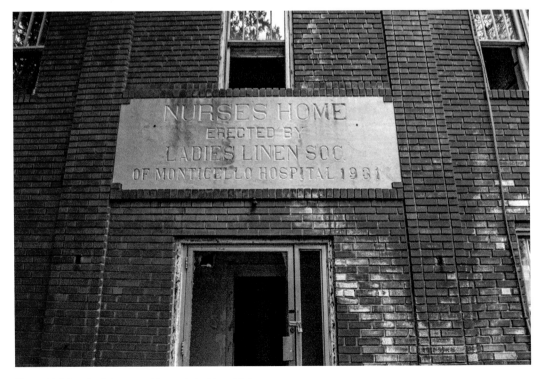

The red brickwork of the nurses' home is just beautiful.

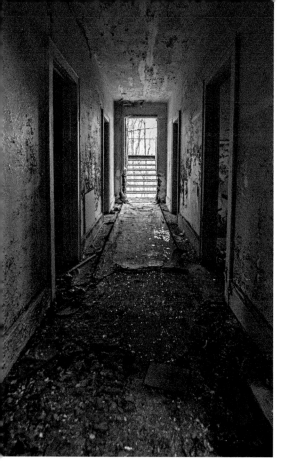

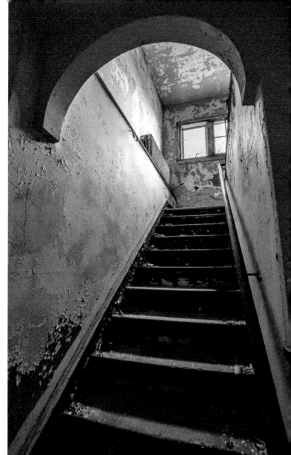

Above left: Garbage and peeling paint line the halls.

Above right: Curved archways are always a fan favorite.

Right: A little bando humor.

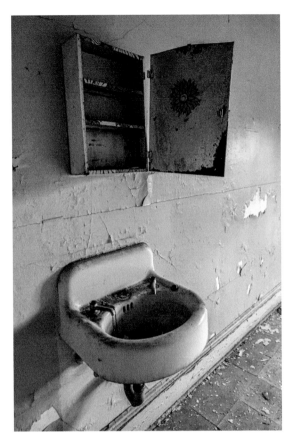

Left: Many of the rooms were fitted with their own sinks and medicine cabinets.

Below: A last look at the halls before we leave the bed bug manor.

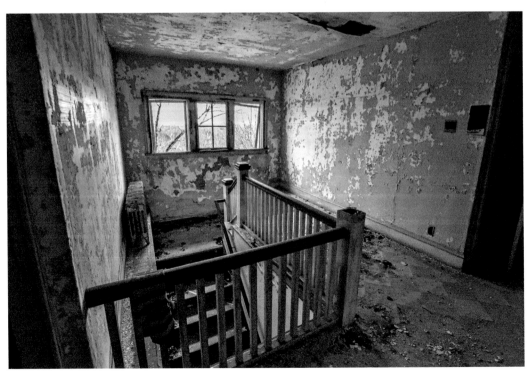

8

CATSKILL GAME FARM

THE ANIMALS HAVE LEFT THE ZOO

For a change, I decided to visit a decaying place that was actually accessible to the public. It is only open to the public a few times a year, but sure, I'll take it. The game farm opened in the 1930s, and facing some controversy about conditions at the zoo in the early 2000s, eventually closed. In 2014, the zoo was reopened by new owners trying to revamp the place for "glamping," weddings, and yes, it is open to urban exploration on specific dates. I love the idea of the new owners taking advantage of the fact that people enjoy urbex, so why not cash in on it? There is a donation suggested, and a waiver you have to sign. Easy peasy.

While the owners have ambitious plans, there are many decaying buildings and pens to see, and so much to explore. Walking along all the old paths, you notice discarded signs from the zoo, old gift shops, and even abandoned baby strollers. You can still enter many of the buildings, so I entered as many as I could where mold did not prevent me. Why didn't I bring my mask?!

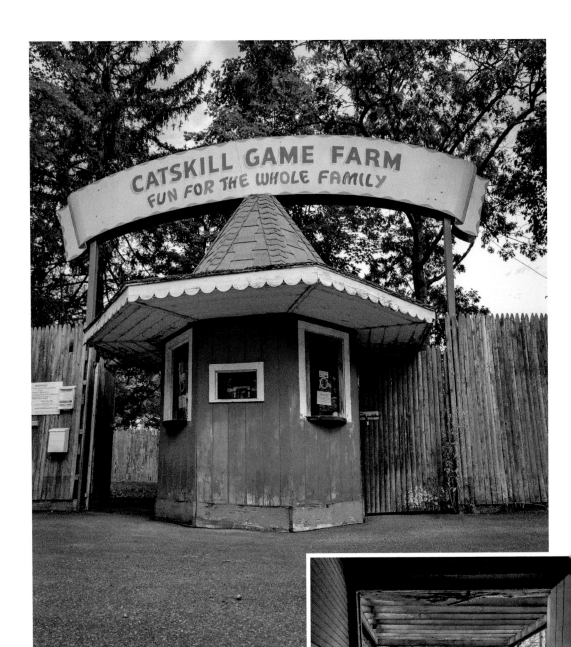

Above: The old ticket booth at the Catskills Game Farm.

Right: Many buildings at the game farm were still fully stocked with forgotten inventory, including a baby carriage.

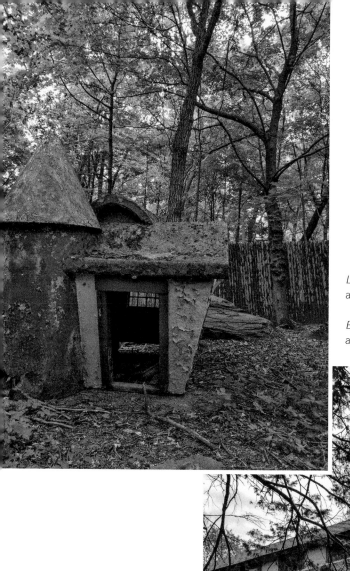

Left: A former holding pen for the baby animals.

Below: All the former buildings holding animals can still be found here.

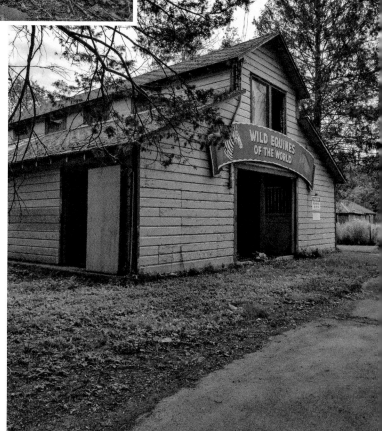

Left: Details of the peeling paint inside the holding pens.

Below: Paper towels still in the dispensers more than ten years later.

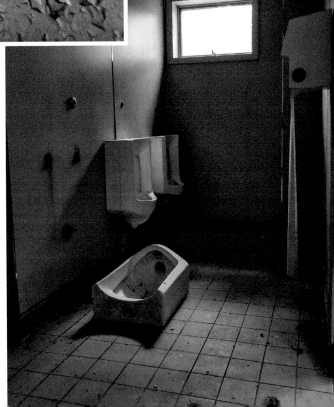

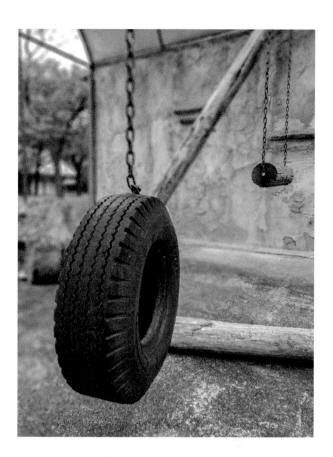

Right: Inside the monkey cage.

Below: Overgrowth is taking over the gift shop spaces.

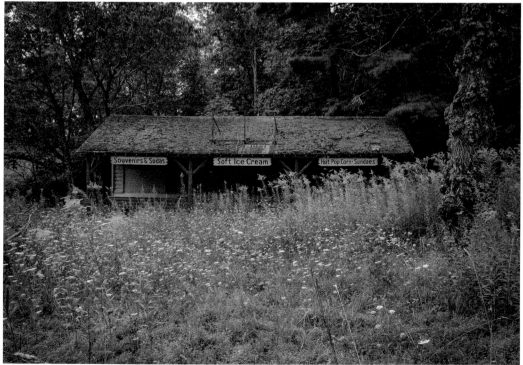

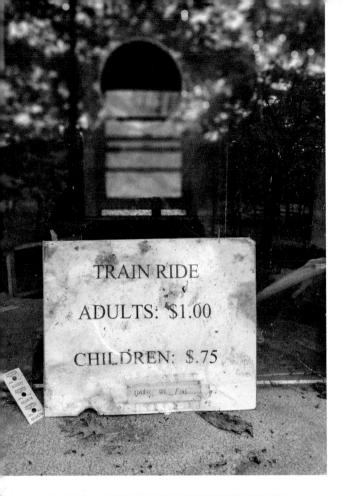

Left: An old sign from the small train on the property that used to carry visitors around the park.

Below left: So much of the office equipment can found be strewn about the property.

Below right: Inside a small shop, I found a can of mac and cheese. I had no idea this was a thing.

Opposite page: I had to climb up into this structure, only to discover there wasn't much to see.

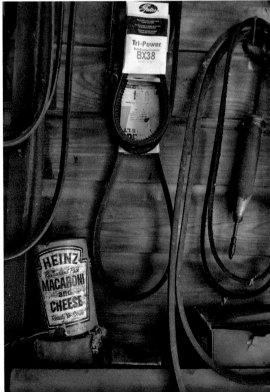

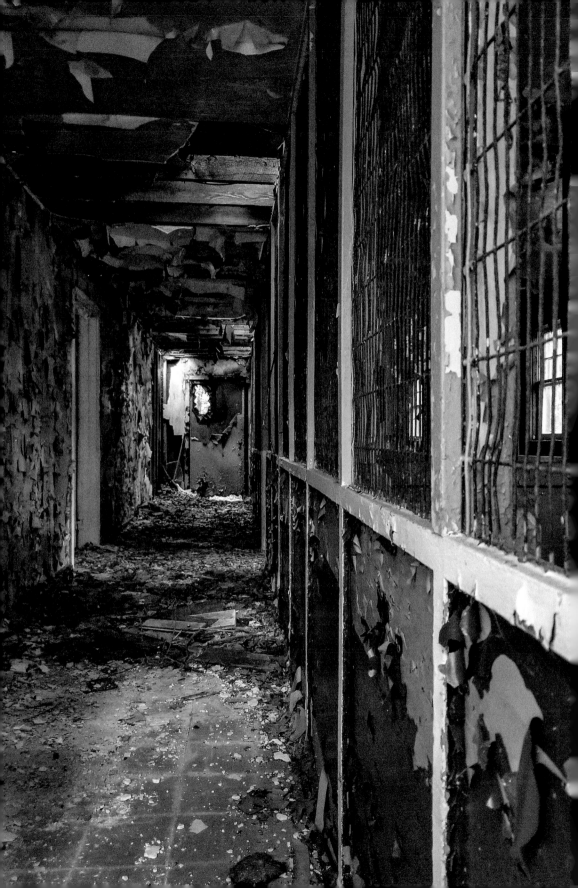

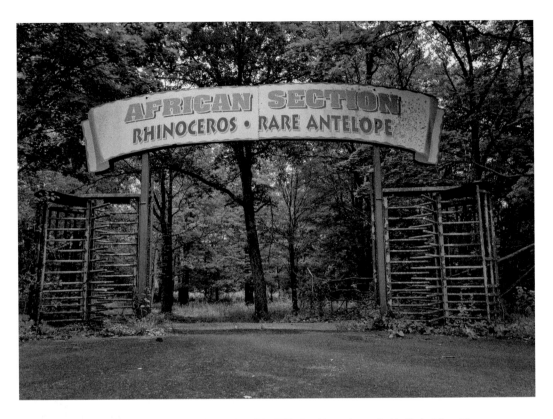

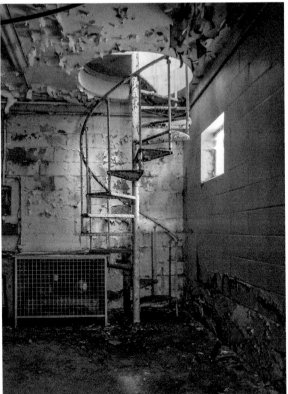

Above: I was glad to find all the old signage survive after so many years.

Left: The hippo house was my favorite space at the game zoo.

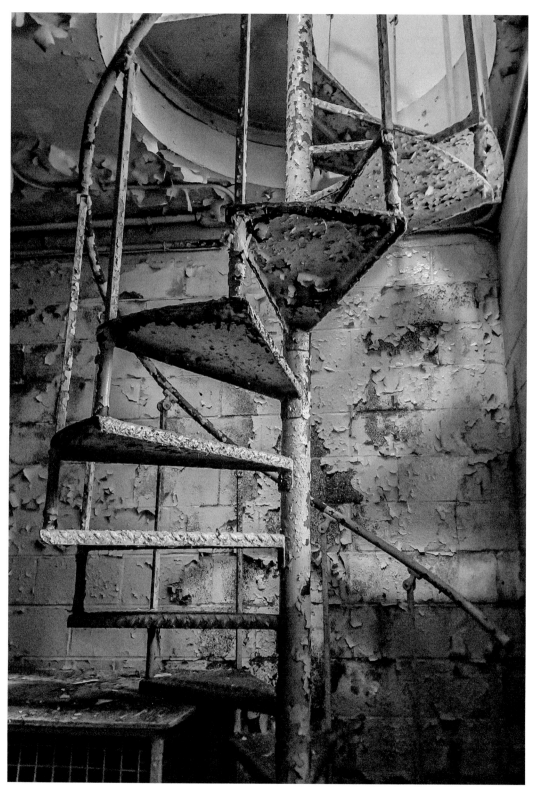

Spiral staircases are absolutely beautiful.

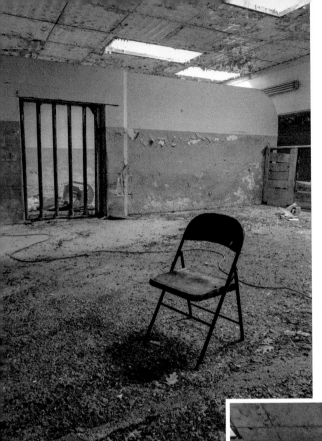

Left: Inside the hippo house, we heard many strange noises. Apparently, these strange noises were due to some lost dragonflies.

Below: Rumor has it that there was some creepy looking doll that is sometimes placed in this building to scare strangers. We had no such luck finding said doll.

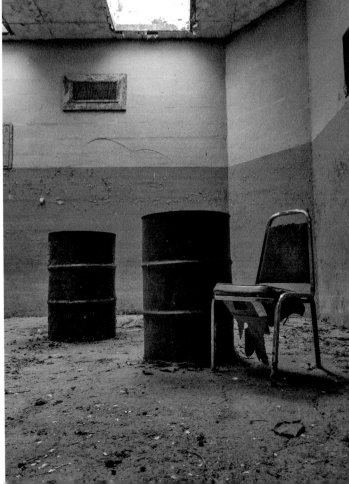

9

THE HOSPITAL AT THE FORGOTTEN BOROUGH

This hospital is a weird one as it lies on the property of an active hospital. Several buildings are fully functional, while parts of the property sit in constant decay. Therefore, it is not unusual to see people around, until you get to that one part …

Years ago, I had visited one of the abandoned buildings on this property, but to say it was a massive heap of rot is putting it kindly. This time when I returned, said building was gone. Apparently, it was bought by a developer and was demolished for future projects. I soon discovered a way to enter another forgotten structure here I had not visited before. This building was certainly in better condition, but sadly contained very little in the way of artifacts of its previous life. You can spot signs for a dental clinic and you can find the children's room with murals or cute stickers on the wall, but it all remains forgotten, waiting for its fate to be decided.

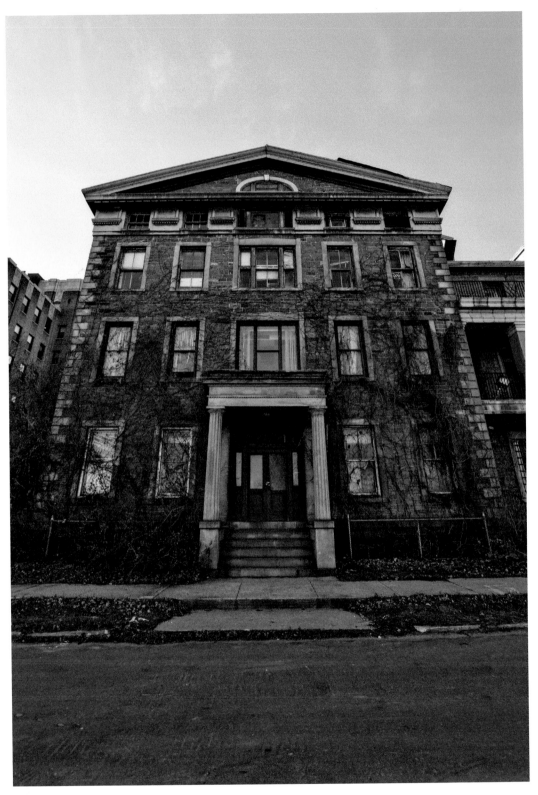

This abandoned hospital building sits right next to a functional hospital building.

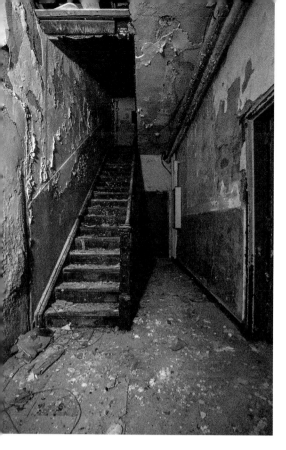

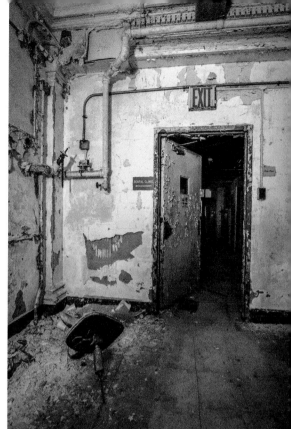

Above left: It was in the middle of the night when I first visited this place and was greeted by the usual crunch under my feet.

Above right: This way to the dental clinic.

Right: Exit the mold filled hallway here.

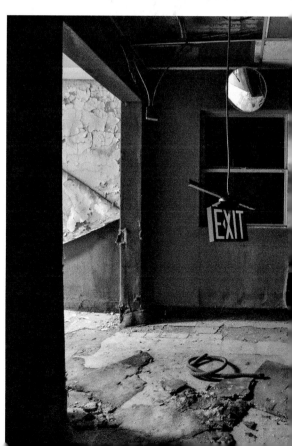

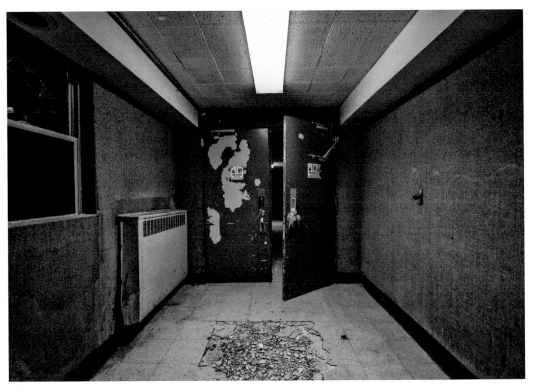

Yes, that is a light that still functions in this empty hallway.

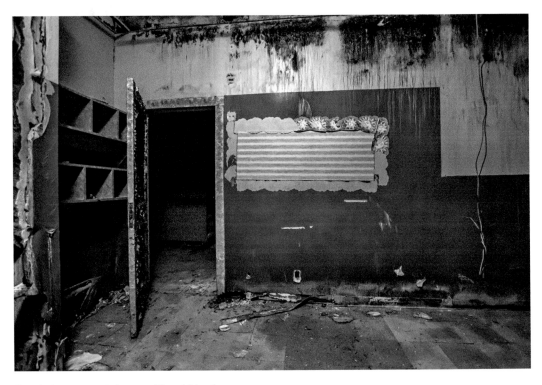

Found what appears to be one of the children's rooms.

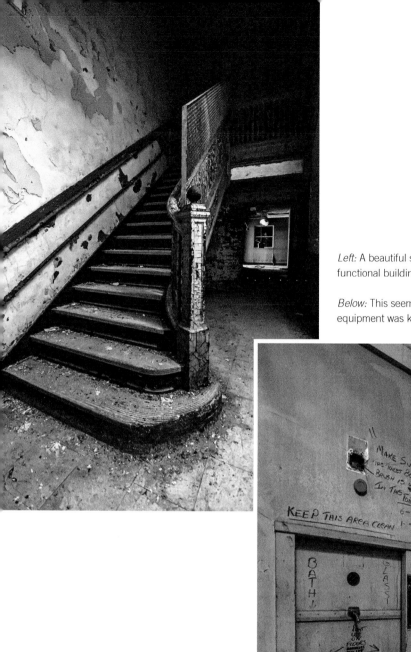

Left: A beautiful staircase with light from functional buildings in the background.

Below: This seemed to be where the janitorial equipment was kept.

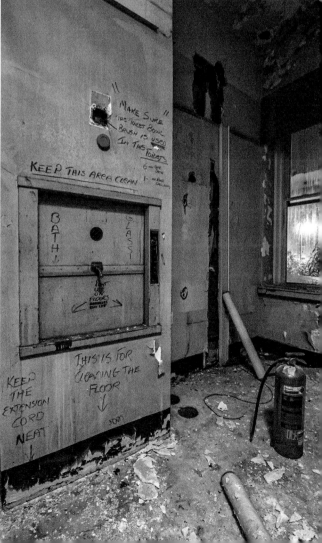

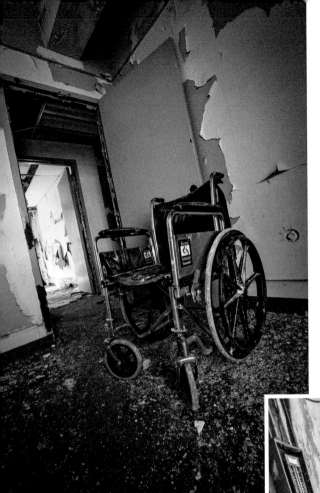

Left: The holy grail for abandoned hospitals: a wheelchair.

Below: Looking down this beautifully decayed staircase.

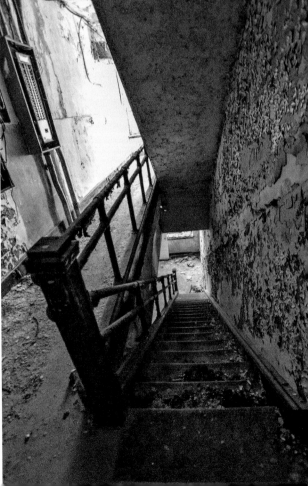

10

THE RESORT WITH THE FUNNY NAME

YOU CAN'T MAKE THIS STUFF UP

If I told you the name of this place, you would not believe me. So, we will just talk about the world's quickest exploration. There is nowhere to park, you have to climb under a fence, and then run quickly through a long field all without being spotted while cars are coming up and down the road regularly. Oh, did I mention all the snow and ice here, too? Yeah, this place was not easy.

We enter through a maze of corridors and have very, very little time to do so. Since there was nowhere to park the car, we have to do this all QUICKLY. Of course, the halls are covered in ice, easily an inch or so. I desperately hang on to the walls so not to do a faceplant while trying to rush towards the bowling alley. Door after locked door, we're getting frustrated and cold. Finally, we arrive at the bowling alley, but where are the pins? These darn vandals, they did not abide by the unspoken urbex rules: no breaking in, no stealing from places, and no destroying anything. Take photos, leave footprints, people! We take a few shots and slide on the ice all the way back to the car. It was easily the craziest fifteen minutes in a bando I've ever spent.

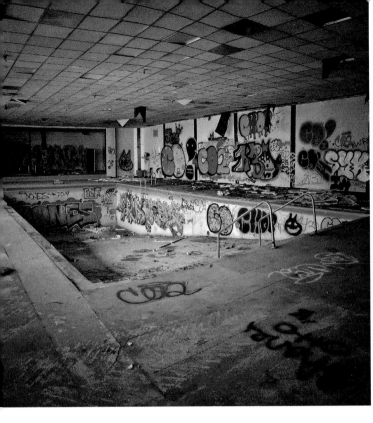

Left: The once beautiful indoor pool at this Catskills resort.

Below left: It took a while, due to many locked doors, to find the bowling alley.

Below right: I found plenty of balls but no pins at the bowling alley.

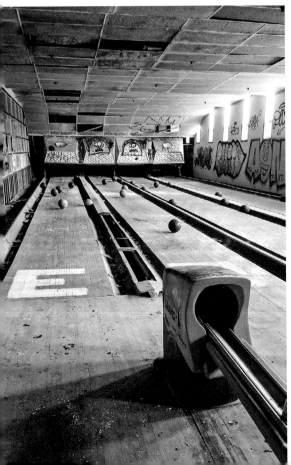

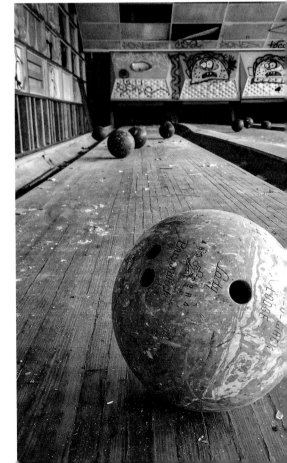

11

JUST ANOTHER BUNGALOW COLONY

THAT'S THE CATSKILLS FOR YA

If you have ever visited the once booming Catskills, you know how much of it lies rotting today. The Catskills were once a place littered with amazing resorts where the city folk would go to escape noisy life. In addition to these extravagant resorts, bungalow colonies were springing up in the area. These too were made to cater to those looking to escape city life in the summer. Although the resorts and bungalow colonies began to see a decline in the 1980s, many of these properties can still be found today as abandoned spaces. I came upon one of these bungalow colonies quite by accident. I was heading to another abandoned location (that did not work out), when I unexpectedly found this property. Many of the bungalows were boarded up, but the few I could peer into were quite dated with furniture from the 70s. Sometimes you can easily identify when a space was abandoned just by the décor. This was one of those places. I walked around for a few minutes in the crisp autumn air trying to document what I could. It was a simple bungalow colony—a space meant for a simple life with merely a pool for recreation. I can only imagine what the Catskills must have looked like in its glory days.

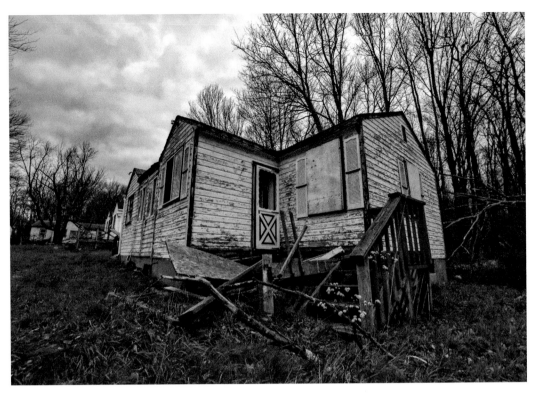

Bungalow colonies can be found all over the Catskills—this was just one of them.

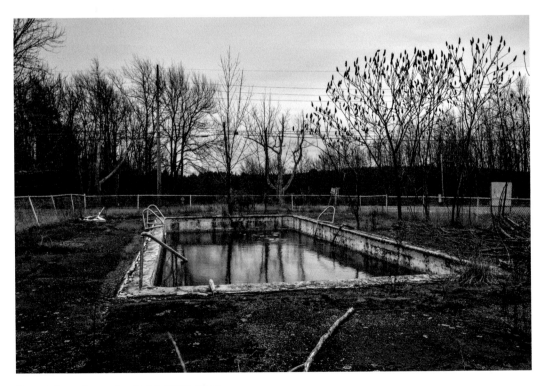

The only form of recreation found at this colony.

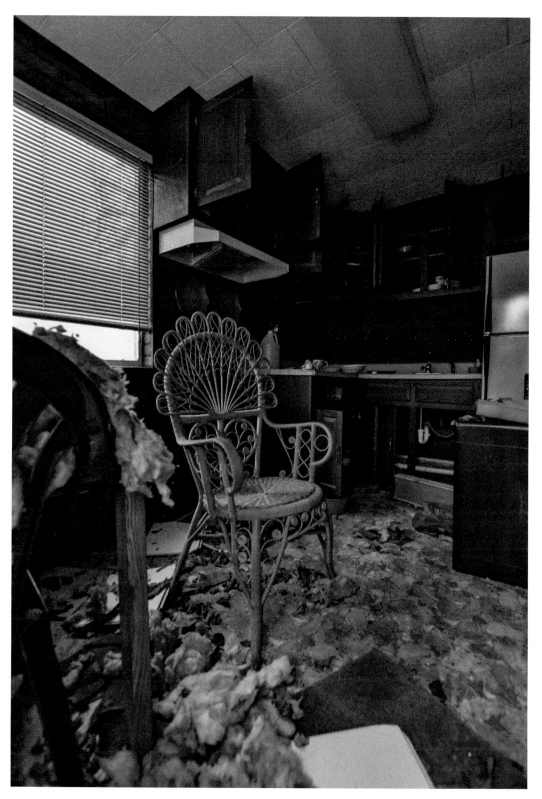

I peeked inside one of the bungalows and was treated with this gem of a chair.

BIBLIOGRAPHY

abandonednyc.com/2012/05/16/the-bayley-seton-hospital-nurses-residence/

alexandracharitan.com (formerly onlylivingirlny.com)

allthatsinteresting.com/new-york-city-farm-colony

atlasobscura.com/places/dennings-point-ruins

en.wikipedia.org/wiki/Urban_exploration

hvmag.com/Abandoned-Catskill-Game-Farm-Zoo-Reopens/

hvmag.com/Hudson-Valley-Magazine/February-2016/The-Real-History-of-Letchworth-Village/

nytimes.com/1991/09/22/realestate/streetscapes-the-farm-colony-historic-or-not-it-s-a-
 jungle-in-there.html

riverreporter.com/stories/land-bank-considers-monticello-manor,34273?

vice.com/en_us/article/nzgpjm/inside-the-abandoned-asylum-that-was-made-infamous-by-
 geraldo-rivera